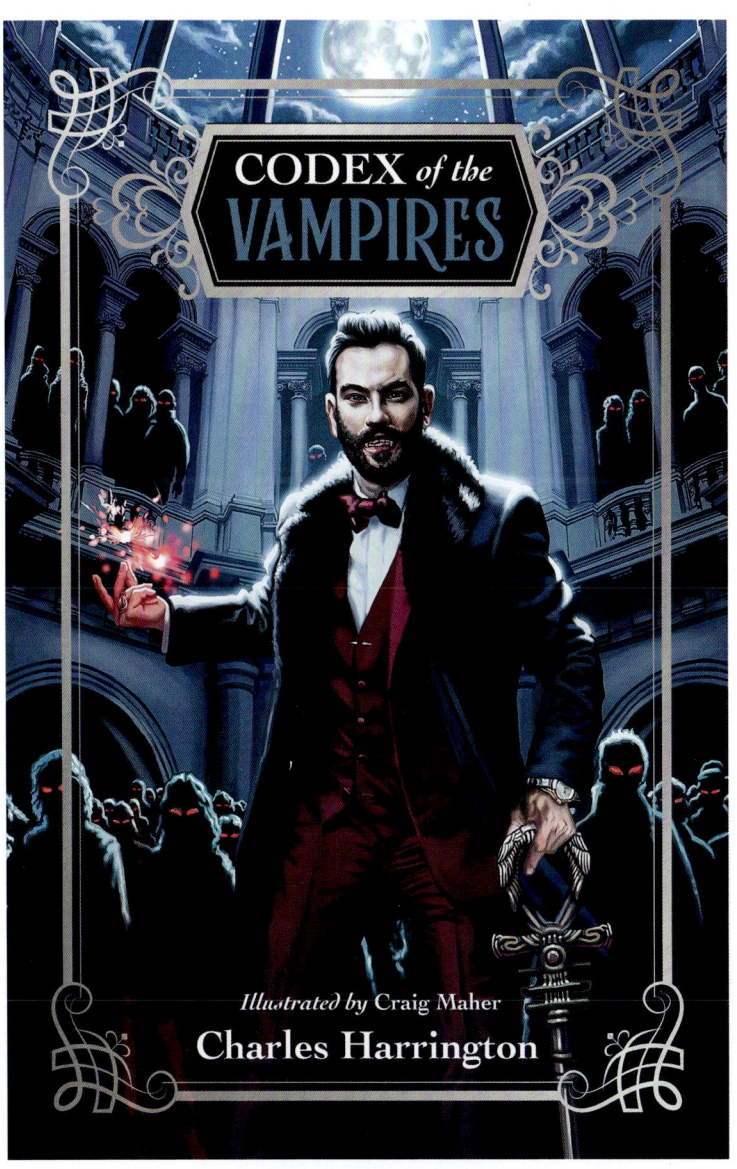

About the Author

Charles Harrington has been reading, teaching, and loving tarot for twenty-five years. He is the author of the guidebooks to *The Murder of Crows Tarot*, *Ferenc Pinter Tarot*, and *Tarot V* from Lo Scarabeo. His love of the cards and connecting with other readers has manifested in cohosting podcasts, speaking at conferences, and leading meetups in the San Francisco Bay area. In his free time, he loves to find new and strange ways to use the cards in pursuit of wisdom, fun, and the occasional free cocktail.

About the Illustrator

Craig Maher is an illustrator creating fantasy and tarot art. Craig believes figurative illustration of otherworldly subjects is the core of storytelling art. Craig began studies with Joe Kubert at The Kubert School. He has won Best in Show at GenCon (the largest game convention in North America) and appeared in Spectrum: The Best In Contemporary Fantastic Art and Infected By Art illustration annual.

Codex of the Vampires © 2023 by Charles Harrington; Art by Craig Maher. All rights reserved. No part of this book may be used or reproduced in any manner whatsoever, including internet usage, without written permission from Llewellyn Publications, except in the case of brief quotations embodied in critical articles and reviews.

FIRST EDITION
First Printing, 2023

Book design by Mandie Brasington
Cover and interior card art by Craig Maher
Cover design by Kevin R. Brown
Editing by Marjorie Otto
Interior spreads and line art illustrations by Llewellyn art department

Llewellyn Publications is a registered trademark of Llewellyn Worldwide Ltd.

ISBN: 978-0-7387-6628-7
Tarot of the Vampires kit consists of a boxed set of 78 full-color cards and this perfect-bound book.

Llewellyn Worldwide Ltd. does not participate in, endorse, or have any authority or responsibility concerning private business transactions between our authors and the public.

All mail addressed to the author is forwarded but the publisher cannot, unless specifically instructed by the author, give out an address or phone number.

Any internet references contained in this work are current at publication time, but the publisher cannot guarantee that a specific location will continue to be maintained. Please refer to the publisher's website for links to authors' websites and other sources.

Llewellyn Publications
A Division of Llewellyn Worldwide Ltd.
2143 Wooddale Drive
Woodbury, MN 55125-2989
www.llewellyn.com

Other Books by Charles Harrington

Murder of Crows Tarot (2020)
Tarot V (2021)
Ferenc Pinter Tarot (2021)
Journey of a Lonely Soul Oracle Cards (2022)

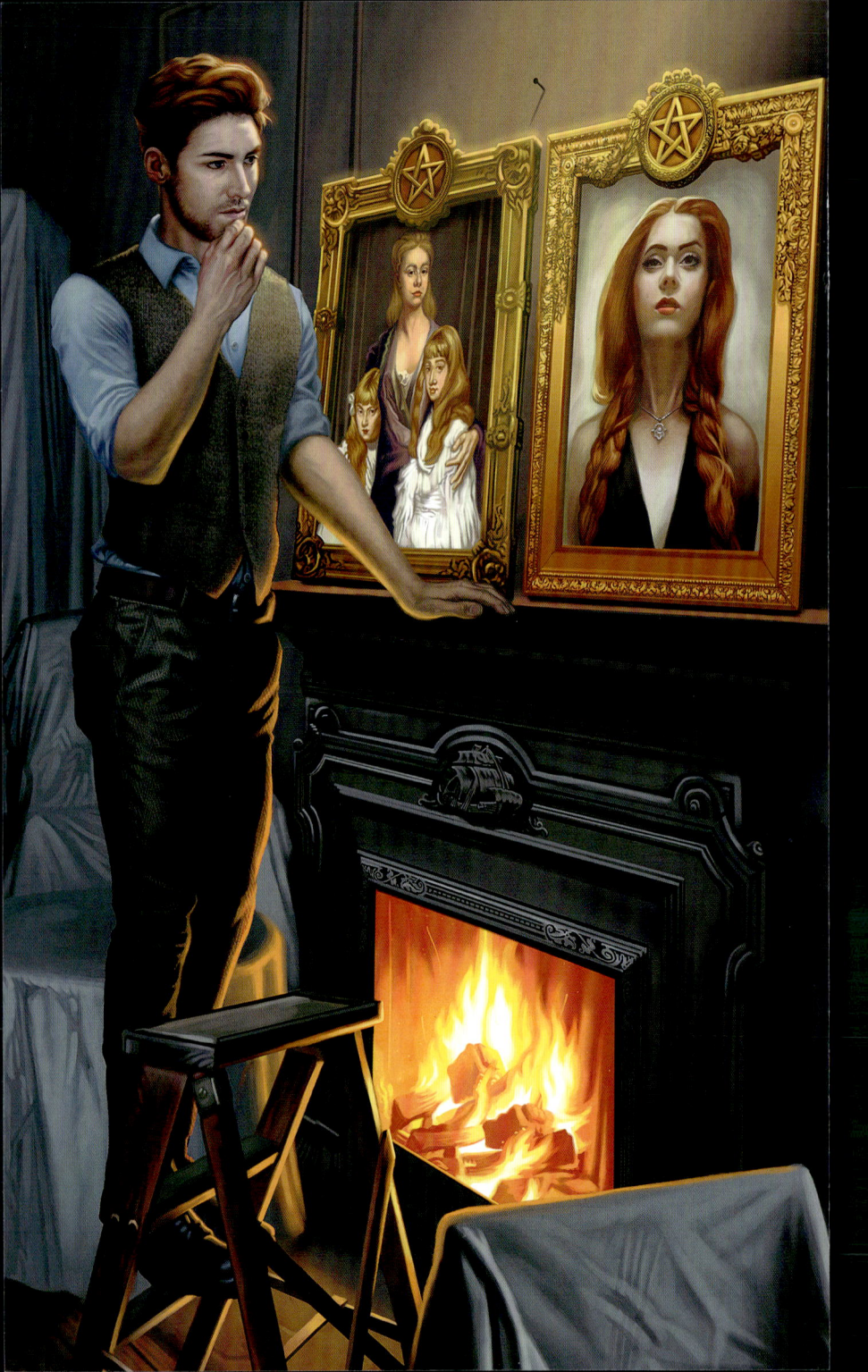

Contents

Come Away with Me… In the Night—1

1–In the Shadow of the Vampire–3
2–A (Mercifully Brief) History of the Tarot–7
3–A Deck of Shadows–11
4–Sinking Your Teeth into Tarot Reading–15
A Practice Reading—16
A Word of Caution—17
Reading Reversals—17
Your Tarot Journal—18
Symbols and Portents—19

5–A Ritual to Bless Your New Deck–21
6–Tarot Spreads–25
The Daily Draw—25
The Four Card Spread—26
The Horseshoe Spread—27
The Crossroads Spread—28
Between Heaven and Hell—29
Shadow Work—31

7–A Grimoire of Meanings–33
The Major Arcana—35
The Suit of Wands—81
The Suit of Cups—111
The Suit of Swords—141
The Suit of Pentacles—171

The Night Is Young… —201

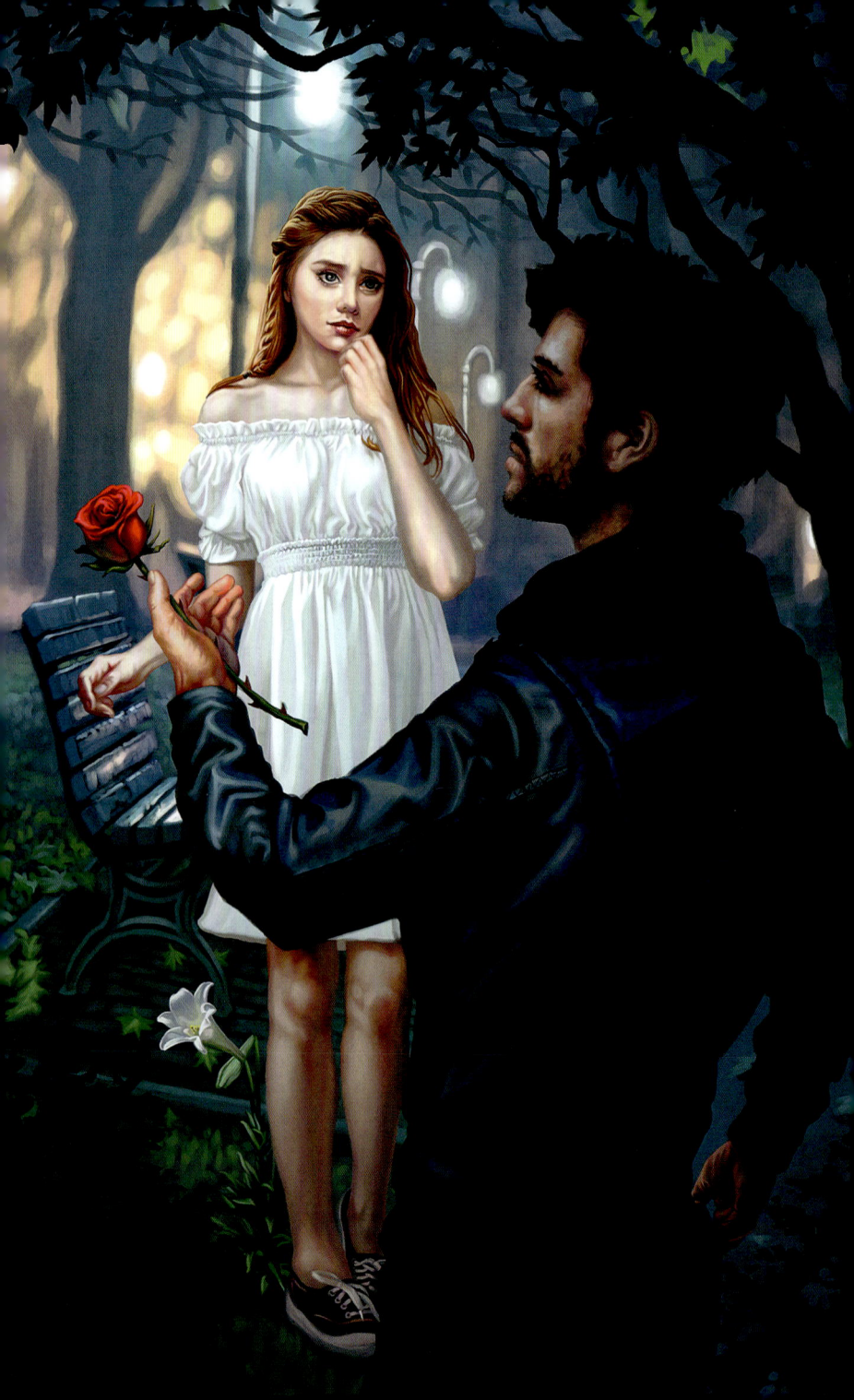

Come Away with Me...
In the Night

Y OU HAVE ALWAYS KNOWN THERE WAS A SECRET WORLD existing alongside our own. You have seen glimpses of it in the shadows, heard its whispers in the night air, and felt the call deep within your soul. The sun sets on the world of mortals; awaken to the night of the vampire.

Within this deck, the living and undead lead an eternal dance suspended between Heaven and Hell. The tale of the vampire, as told in these cards, is of powerful beings struggling to do what is right in a world that can be dark and terrifying. This is your tale as well, and, just like the children of the night, many wonders exist within you that will be discovered when you can see yourself for all that you are. Forgotten treasures can be found within the shadowy places, so shuffle the cards and uncover what has been lost.

In darkness and in light, you shall see and be seen.

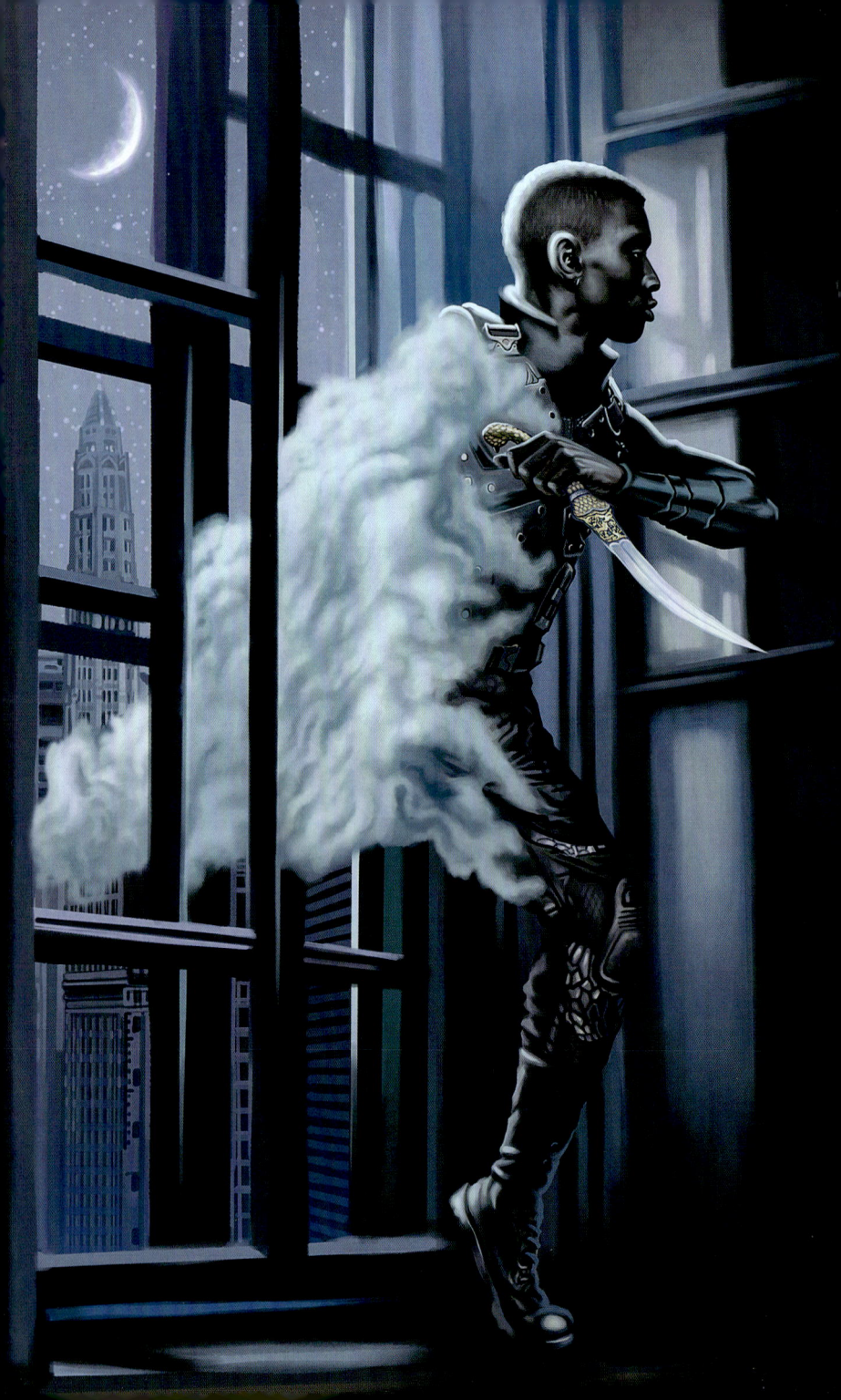

Chapter 1
IN THE SHADOW OF THE VAMPIRE

VAMPIRES HAVE BEEN ONE OF OUR MOST IMPORTANT CULtural shadows for more than a century. Their mysterious origins come in part from the Romanian *strigoi*, the spirits of the unquiet dead who rise from the grave to menace the living. In the hands of writers and artists, their nightly hunts and unending lives have been an evocative metaphor to explore all our darkest fears and most potent desires.

In 1897, Bram Stoker's novel *Dracula* terrified prim and proper British and American audiences with its tale of a foreign nobleman who brings his old-world mysticism into England. The count takes up residence in an abandoned abbey with boxes of tainted soil and preys upon virtuous young women, turning them into monsters. Not very subtle, is it?

Each generation has chosen to create and evolve its own vampires to play out their new forbidden fantasies in poems, novels, films, television series, and comics. In these stories, the monsters and their powers have been used to explore such

taboo subjects as female sexuality, queer sexuality, gender nonconformity, drug use, teenage rebellion, religion, mental illness, and, always without question, our fears concerning death and mortality.

As you can imagine, this has made vampires a compelling archetype for anyone who felt as though they were "on the outside."

In the last century, something new arose in vampire fiction: the vampire as tormented hero. Examples of this new archetype include Louis from *The Vampire Chronicles*; Barnabas Collins from *Dark Shadows*; Angel and Spike from *Buffy the Vampire Slayer*; Bill and Jessica from *True Blood*; Edward and his family from *Twilight*; Stephan, Damon, and Elena from *The Vampire Diaries*; and many more.

Pagan author and journalist Margot Adler made an extensive study of vampire fiction and identified these characters as *moral vampires*: powerful creatures with incredible abilities struggling desperately to do what is right. That description holds up a dark mirror to modern human beings. We are aware that we have vast wealth and wondrous technology paid for by draining the planet's resources and oppressing lower income populaces. We are also aware that, despite our many advancements in the sciences, we are going to age and die.

Vampire fiction allows us to delve into these dark places, to imagine what it would be like to be young and beautiful forever, and asks us how we would cope with accepting that gift if it required us to drain the vitality from others.

You've thought about it, haven't you? What would your decision be—would you accept a life of eternal night? And if you did, what would you do with the abilities you were given? What shadows stir within you, just below the surface longing to be freed?

The unlife of the vampire is much more than shadows and taboos. There is also astounding beauty, joy, and even heroism to be found among its kind, and you will find those things present in

this deck. The *Tarot of the Vampires* depicts the nightly struggle of humans and vampires to make sense of their own existence, face their fears, and find their dreams.

It has been said that vampires are the most appealing monsters to humans. Unlike other creatures of the night, they tend to be quite attractive, they are impervious to most forms of damage, and they don't have to worry about a day job. Most importantly: they have the preternatural skills to achieve their ambitions and an eternity to enjoy them.

A tarot reading begins with a question, and a question hints at unfulfilled desires. A tarot reading can help you size up your prey and suggest a winning strategy that will allow you to move in for the kill.

A vampire must also learn to live and move among normal human beings—if they are found out, hunters and torch-bearing mobs are not far behind. And, in quite a bit of modern vampire fiction, they are ruled by intricate and often territorial shadow governments. The tarot has much to say about the complex relationships and social structures we find ourselves in and how to navigate them with a minimum of conflict (or how to come out on top when conflict arises).

And vampires are *extra*. They are essentially like us but with the addition of some fangs, secrets powers, and a killer wardrobe. Identifying with them and their stories in a reading gives us permission to be extra as well. The tarot, most significantly of all, can show us how to perform the most seemingly impossible feat imaginable: to change ourselves. These seventy-eight cards have been a tool of personal transformation for more than two centuries and, like the abilities that vampire bloodlines pass through the centuries, they have now come down to you.

Seek out that which you desire.

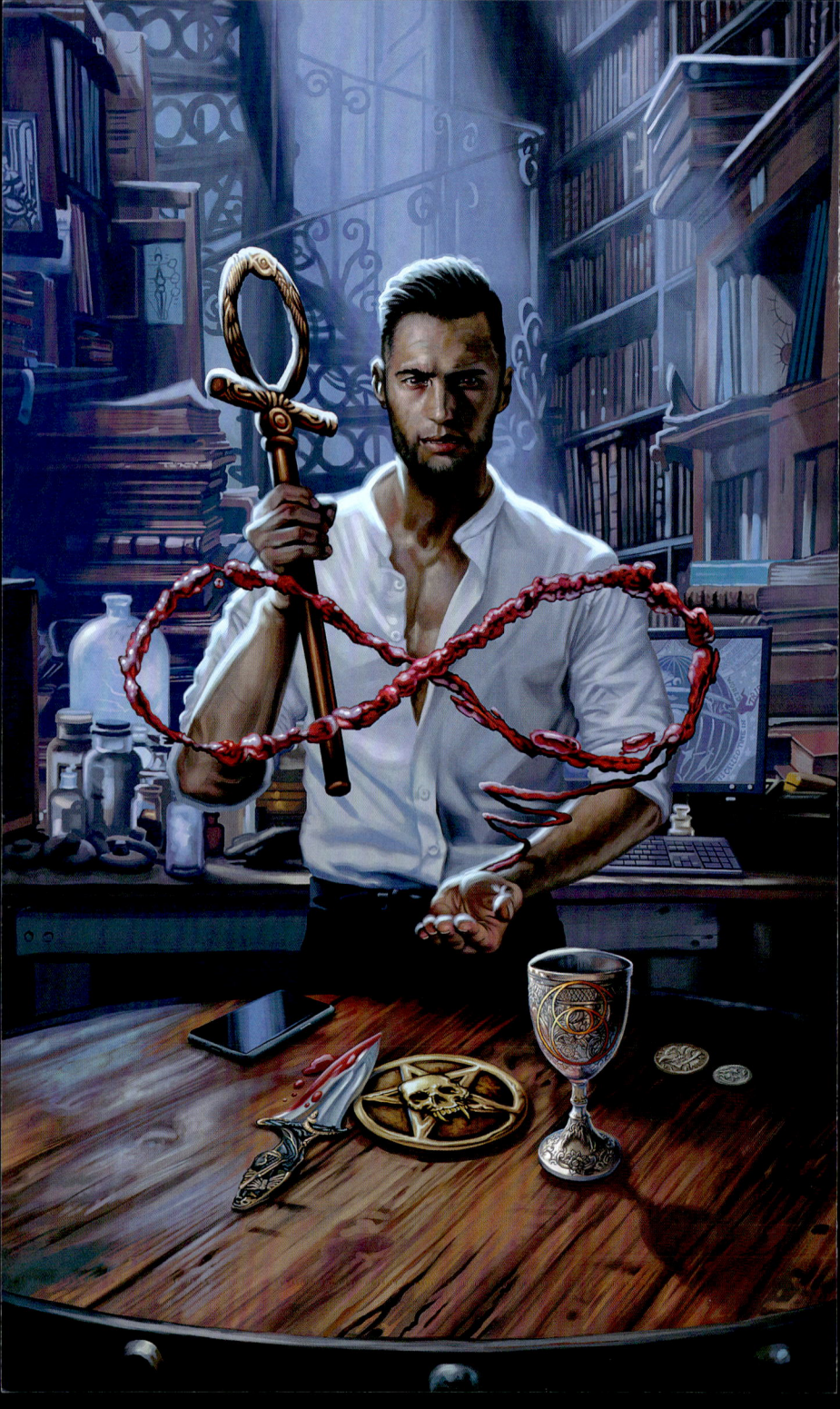

Chapter 2
A (Mercifully Brief) History of the Tarot

Tarot cards began their strange, wonderful journey as a playing card game in Italy in the 1400s. It was distinguished from other playing card decks of that era by containing a special suit called the *trionfi* (triumphs) that featured allegorical images. In the more formal version of the game enjoyed by Italian nobility, the players came up with clever observations based on the cards that appeared—for example, complimenting the host on his distinguished military career when the Chariot was played.

In the late 1700s, occultists looked at the cards of the *trionfi* suit (today called the major arcana) and assumed that the deck was coded with secret information from the Kabbalah (an esoteric Jewish mystical tradition). They were incorrect but their ideas led to the creation of a body of writing about the cards and the development of techniques by which the practitioner could achieve tremendous spiritual growth and divine the future by meditating upon them.

In 1909, the tarot experienced another critical transformation. Arthur Edward Waite and Pamela Colman Smith (who was a friend of Bram Stoker, the author of *Dracula*, as it would happen) created an evocative new deck, the Rider-Waite-Smith tarot deck. The deck featured scenes on all cards of the minor arcana. This change (and Colman Smith's captivating artwork) made the deck infinitely more relatable than ever before, and many new books were written about working with the cards that did not rely upon the reader having a vast knowledge of complicated arcane information.

The tarot enjoyed several decades as a tool for fortune-telling before its body of use expanded once again. In the 1970s and 1980s, tarot readers began to use the cards to explore psychological lines of questioning and the role of the reader's intuition in the process was given a greater emphasis.

Why is it important to know any of this? I'll give you two reasons.

First, rather than changing from one thing to another, the tarot has broadened and deepened to include many facets. You can still play card games with it, employ it as a focus for philosophical contemplation, tell fortunes with it, and allow it to guide you through your own inner landscape. It is a versatile tool to be used in the ways you find most interesting.

Second, new practitioners often fear they cannot perform readings correctly unless they know the *true* meaning of each card, and they may become confused when books offer conflicting interpretations. As we know, since the deck began as a playing card game with no connection at all to divination, *there is no one true original meaning for any card*. Various books, teachers, and

your own observations will blend to help you accumulate your own storehouse of meanings over your lifetime. Knowing this can help us set fears of inadequacy aside so that we can shuffle the deck and begin to read.

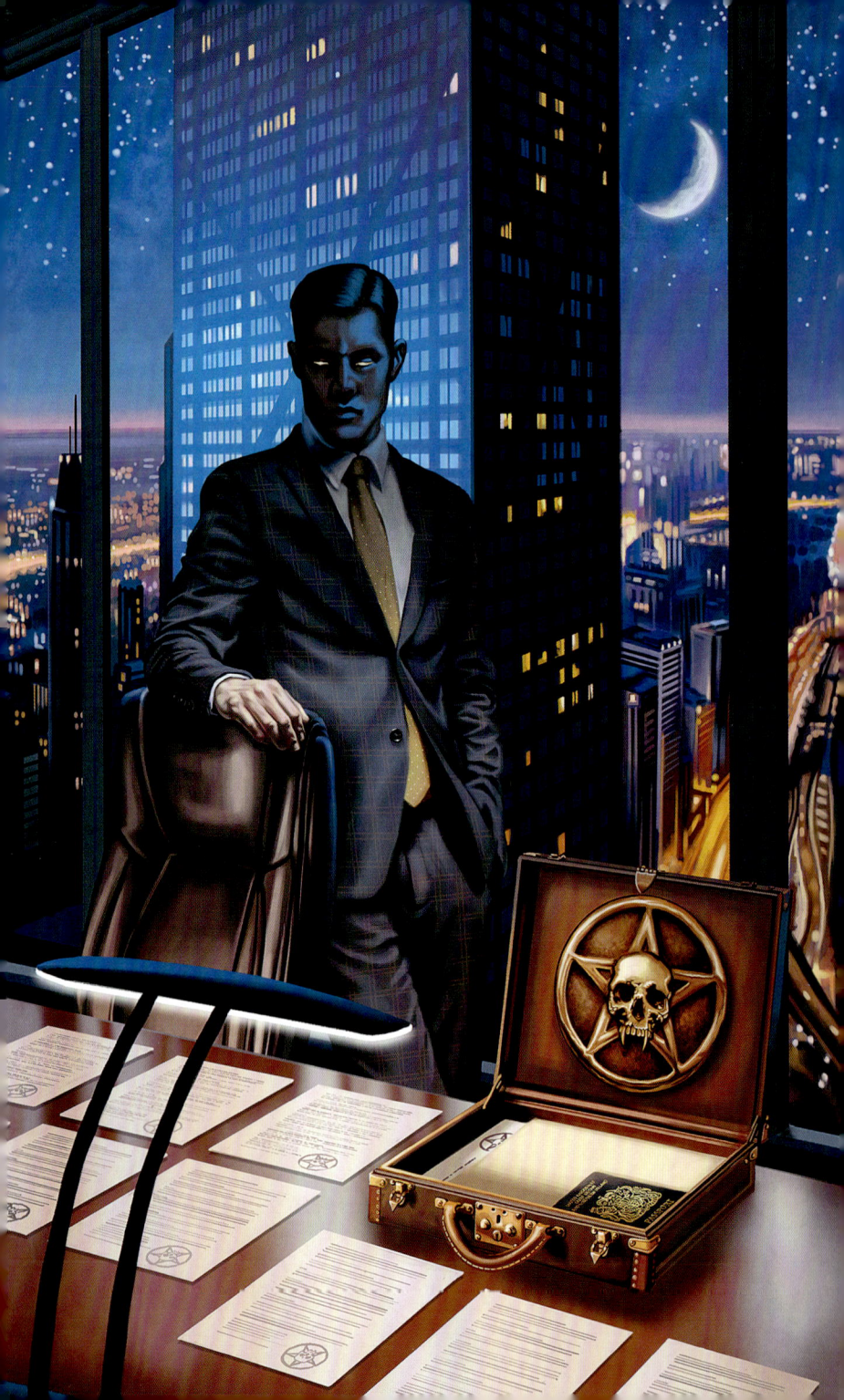

Chapter 3
A Deck of Shadows

The *Tarot of the Vampires* incorporates the potent symbol of the modern vampire to assist you in your own explorations of the mysteries of life and questions about your future. It is a part of the Rider-Waite-Smith school of tarot, the most common form of tarot deck in the English-speaking world, and the meanings for each of the cards will coincide closely with decks of that kind. I was once told that if you want to know whether a deck is in the Rider-Waite-Smith tradition, look at the Six of Swords. If it has a boat on it, you can be certain that it is in this family of decks.

The scenes and characters on the *Tarot of the Vampires* cards draw their inspiration from popular modern vampire fiction, but you do not have to be familiar with any particular books or movies to read with the deck. Fans of vampire stories will probably identify many of these influences, but to understand the cards all you need is the deck, this guidebook, and your own intuition.

The structure of this deck is very traditional. It consists of seventy-eight cards divided into five suits. Four of those suits form the minor arcana (*arcana* means *secrets* or *mysteries*) and the fifth suit that makes tarot stand apart from other playing card decks is the major arcana.

The major arcana contains the twenty-two cards we most strongly associate with tarot: the Fool, the Lovers, Death, etc. These cards are associated with the powerful transformations we experience in life. Influential tarot author Eden Gray coined the term "the Fool's Journey" for the majors, suggesting that they show our evolution from naivete in the Fool toward spiritual evolution and self-awareness in the World. This deck approaches that concept by following the journey of a new vampire. We meet her as an innocent mortal, witness her death and resurrection, and eventually her transformation into... well, you'll see.

The minor arcana cards are associated with everyday life—the many decisions, conflicts, and activities we get up to most of the time. In this deck, these scenes depict various aspects of a vampire's existence from seeking out prey to reveling in their powers and abilities.

Details about each of the suits and the parts of vampire society associated with them appear in chapter seven, ahead of the individual card interpretations for their suit.

THE VAMPIRE COURTS

Within each suit of the minor arcana are four court cards: the page, knight, queen, and king. These cards are strongly associated with people and personalities. In a reading, they will be interpreted in two distinct ways: as a person or as an aspect of yourself.

- When a court card represents a person, it will signify someone in your life who has the qualities associated with the card. The card's position and surrounding cards will tell you how this person may help or hinder you.
- When a court card represents an aspect of yourself, it points to your own qualities that are associated with that card and suggests a strategy you might consider in the matter you are reading about.

Your intuition and the spread you are using will help you determine which way to read the courts.

Vampires famously don't tend to concern themselves with society's gender norms. Similarly, the gender of the characters in the cards, including the court cards, should not be taken literally in a reading. For example, the King of Swords can easily represent a woman or nonbinary person who is taking a careful, strategic approach to their situation.

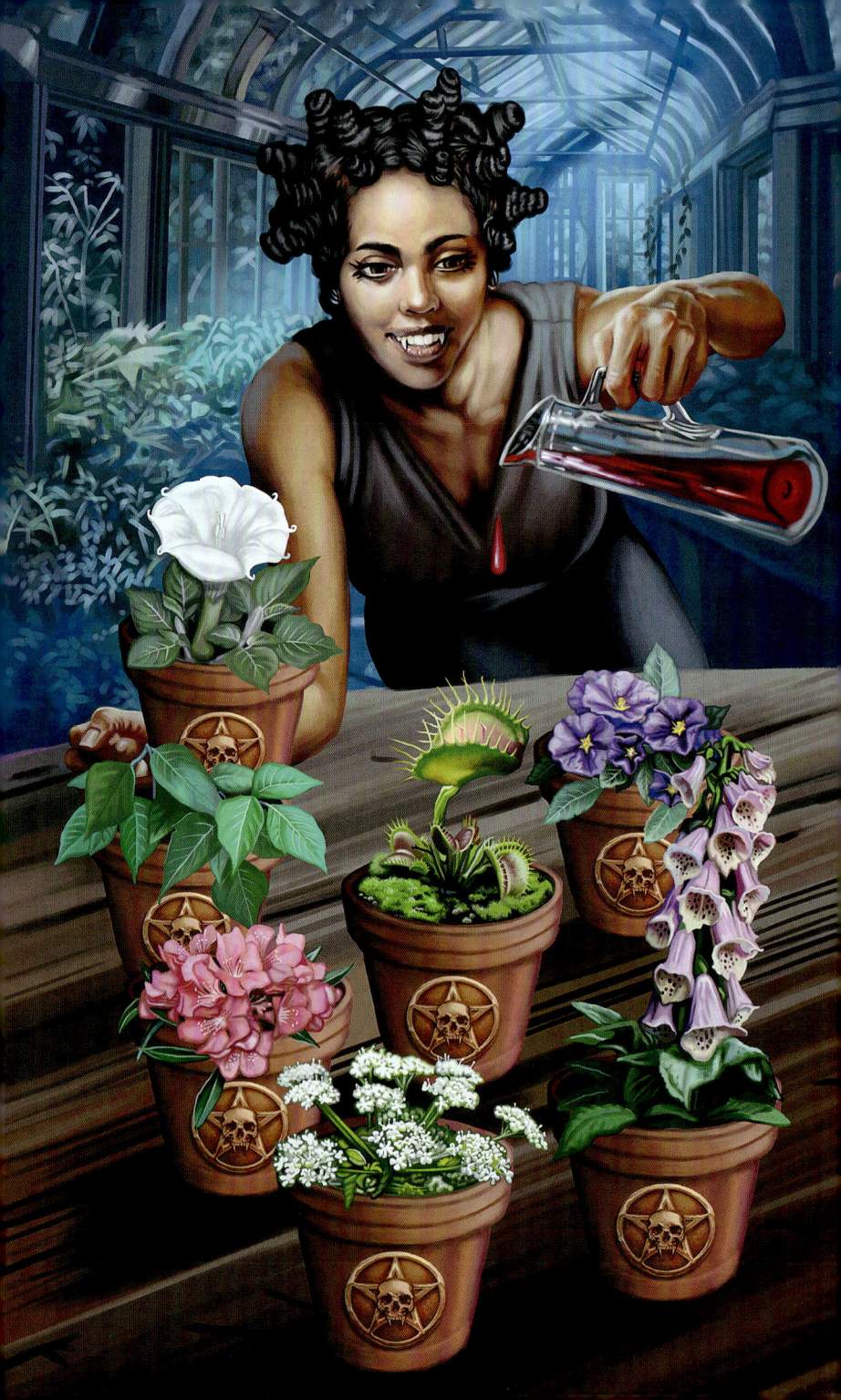

Chapter 4
Sinking Your Teeth into Tarot Reading

The word *divination* comes to us from the Latin *divinare*, which means "to foresee" or "to be inspired by a god." A tarot reading, a form of divination, functions as a sacred conversation between you and your understanding of the divine—be that a god or goddess, the universe, or even your own psyche. The aim of this conversation is to ask a question of the divine and receive an answer that provides insight.

For many, this includes making predictions about the future, but for others the most interesting method of reading tarot cards is as a tool for inner reflection and contemplation. The idea in this sort of reading is that the answer to your question lies somewhere within you, and by considering the images and stories depicted in the cards you will uncover the answer that is most right for you in your situation. Both methods are valid.

Like any other skill, your ability to read the tarot successfully and confidently requires practice and a desire to learn.

Most readers' first efforts are clunky, but with time and repetition, they will develop a familiarity with the cards' meanings and the intuitive sense for how those meanings answer your questions.

A Practice Reading

Let's begin now. Take your cards and consider an area of your life you would like greater insight into (for example your romantic life, job, relationships with friends and family, etc.).

Mix the cards together however you like, (gently) bridge shuffling if you are able or hand-over-hand is just fine. Cut the cards, stack them together, and place the top three cards face-up on the table in front of you from left to right. For this simple reading, the cards represent the past, present, and future regarding the subject of the reading.

Now that the cards are laid out before you, become aware of your first reactions. Is there one card that made you excited or disappointed or that seems to be leaping out at you? Is there a mood that pervades the reading? Imagine the cards tell the beginning, middle, and end of a story. If you had to sum up the story in a few sentences, what would it be? Does the story you just told resonate in any way with your own life?

Now you are ready to tackle the reading card by card. Starting with the first card on the left, look up its meaning in this book and try to determine how that meaning applies to your situation. If you get stuck, start by saying something like "In the past I…" and finish the sentence based on what you just read.

After you have looked up the meanings of all three cards, are there any insights you feel you have received from the reading? Is there a strategy you wish to attempt or even avoid?

Boom. You're a tarot reader.

It is not necessary to memorize the meanings of all seventy-eight cards before you can begin reading them—that's why you have this handy guidebook to refer to.

A Word of Caution

As you have seen, tarot cards are a wonderful tool for exploring many aspects of our lives and possibly getting a peek at our future. But self-examination can also feel a little overwhelming and we can become unnecessarily judgmental of our thoughts and actions. Be kind to yourself on this journey. Remember that the most challenging readings can lead us to unexpected solutions, especially when we share them with others. Above all else, if you find your readings are bringing things to the surface that you are not equipped to deal with on your own, it is a good idea to seek out a qualified therapist who has the specialized training to help you process what you are experiencing. Again, be kind to yourself.

And when you read for others, be humble. When we read the tarot, it is easy to feel like an all-knowing oracle—but we all make mistakes. Do your best, let the querent make their own choices, and try to leave them in better shape than you found them.

Reading Reversals

Reading reversals is a slightly more advanced technique that can give added insight to a reading. In brief, the reader shuffles the cards so that some of them will appear upside down—when you cut the cards to shuffle, simply turn the right pile 180 degrees. When interpreting the spread, the meaning of the reversed cards is shifted slightly.

Most commonly, a reversed card is seen as "blocked" or "delayed." For example, the Ace of Wands can mean an exciting new beginning. However, a reversed Ace of Wands may indicate that the querent desires a new beginning, but something is keeping it from happening. Others interpret the reversed meaning as "internal," so in our example: something exciting is beginning inside the querent. When court cards are reversed, they tend to indicate the character's personality traits are taken to extremes.

Reversals have a bit of a difficult reputation as their meanings often feel negative, but please remember that life has its ups and downs and being willing to see them will allow us to adjust our strategy. Basic reversed meanings are provided with the card descriptions in this guidebook, but in time you may develop your own approach to reading them.

And of course, many readers choose not to read reversed cards, instead relying on their own intuition and the spread they are using to indicate which meaning of a given card applies. The choice is yours.

YOUR TAROT JOURNAL

There is a very high correlation between people who like tarot cards and people who like fancy journals.

One of the most important tools of the new reader is a journal. It can be any format you like, including an app or document stored in the cloud. All that matters is that you choose a medium that you enjoy and find easy to work with.

A tarot journal serves two purposes:

- It forces readers to slow down and give themselves complete readings, thoroughly considering the meaning of each card.
- It will provide a means to track your insights and predictions that you can return to in the future. A card that didn't make sense during a reading might have its meaning revealed later, giving you a deeper understanding of the cards' potential meanings.

To make your journal as effective as possible, be sure to note the date, your question, the spread (more on spreads in chapter 6), each card that appeared in the reading, and (most importantly) your interpretation of each card.

Symbols and Portents

In order to keep the *Tarot of the Vampires* as accessible as possible, we have avoided adding esoteric symbolism to the card images. Specifically, you will not see any astrological or Kabbalistic symbols in the deck because you do not need to know anything about astrology or Kabbalah to read with it. Along with the suit emblems (discussed in their own sections) there are just two symbols to note:

- **Lilies** represent mortals and humanity. They symbolize the purity of the untainted human characters in the deck.
- **Roses** symbolize vampirism and the sensual life of those who have chosen eternal night and awakened to their own desires.

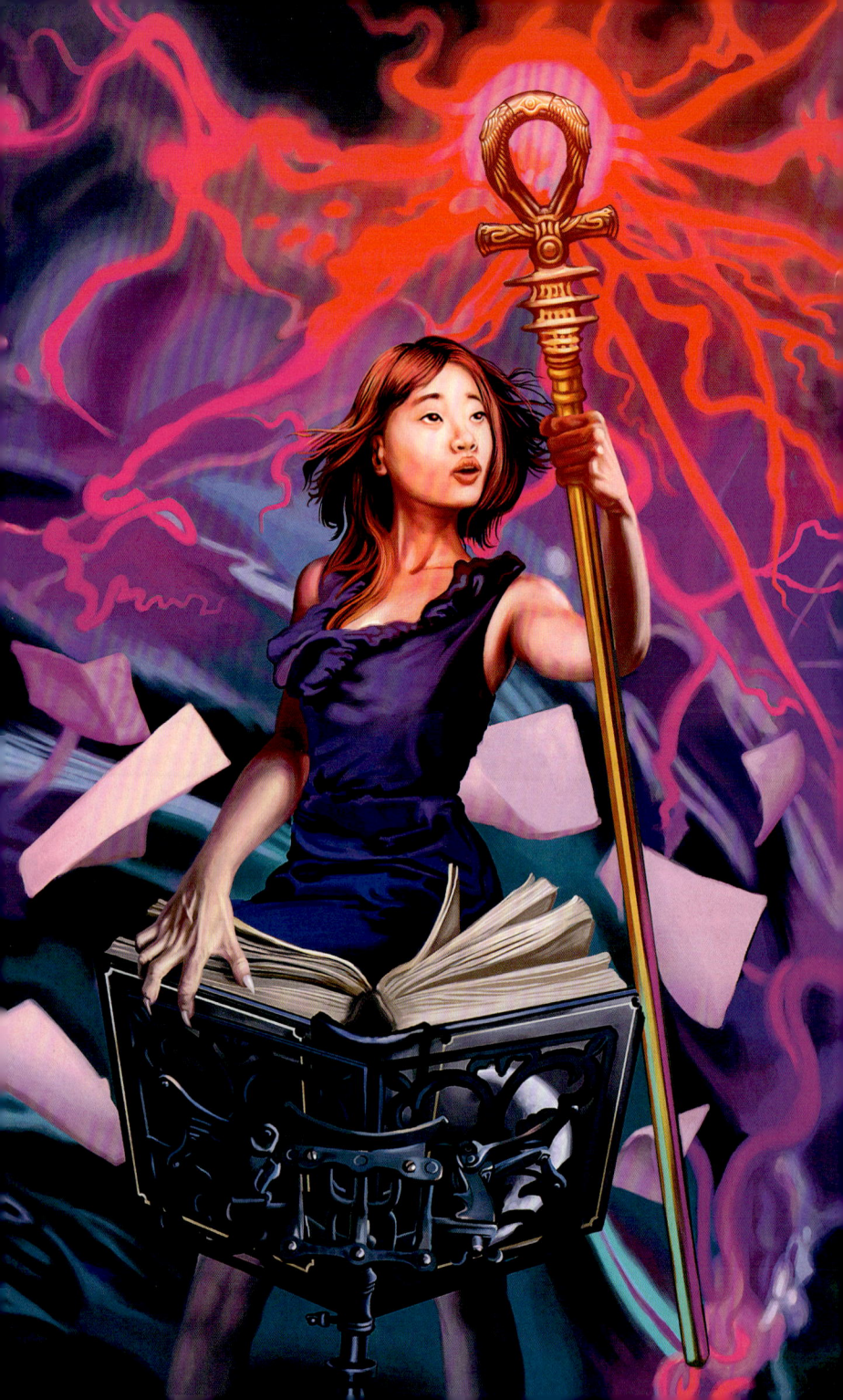

Chapter 5
A Ritual to Bless Your New Deck

As has been demonstrated, you can read the tarot straight out of the box with no other preparations, but a special ritual to consecrate your deck to your purpose can create a unique bond between the reader and the cards. There are many of these to choose from, but here is one for you to try out specially designed to work with the *Tarot of the Vampires*.

Perform this rite on the first night of the waxing moon, when it appears as a slender sickle in the sky. Begin after it rises over the horizon.

Take a cleansing, relaxing bath, adding herbs or oils that can help calm your mind (lavender is an excellent choice). With perfumed oil or pure water, trace the symbol of the crescent moon on your forehead. Imagine that a third eye, the eye that can see beyond the surface of the world, begins to open.

Adorn yourself with any clothing and jewelry that helps you feel like a vampire or in any way magical. Spend a moment exploring what it might be like to be a mysterious creature of the night with preternatural gifts and insights. If feelings of

silliness arise, simply smile, acknowledge them, and let them pass on. No one said spirituality can't be fun.

Place your deck on a special table or altar that you have arranged with objects that help set a mystical mood. You can make use of attractive fabrics, candles, crystals (especially amethyst, moonstone, and carnelian), statues you find inspiring, and anything else you like. Just be sure to leave some space free at the center of the table to work with the cards.

Light a consecratory incense like frankincense, myrrh, or sandalwood and pass your tarot cards through the smoke. Visualize any energies that do not serve your purpose being dispersed as the deck becomes empowered as a tool of insight.

Now place the cards over your heart and sit in stillness. Feel the steady beat of your own heart as it pumps blood through your body, giving you life (you may feel the pulse in your wrist if that is easier). See your own mystical energy field moving through you and your tarot deck in time with the beating of your heart. Stray thoughts may emerge, but you can simply acknowledge them and allow them to drift away as you return your mind to the ritual at hand. Breathe deeply and bask in the wonderful feeling of this universal, vital energy moving through you and the cards until the deck feels like it is a part of you, an extension of your own will.

Speak these, or similar, words:

May this deck be a guide to me in all the dark places I must walk.
May it help me uncover what was, what is, and what may yet be.
May it open my eyes, that I might see and open my heart that I might understand.
May it do these things for the greatest good of all, harming none.
So mote it be.

Shuffle the cards until they are thoroughly mixed and cut them into three piles. Turn over the top card of the first pile. This card holds an important message for you about your past and what has brought you to this moment on your path as a diviner.

Turn over the top card of the middle pile. This card holds an important message about your practice as it currently exists and your unique talents and abilities.

Turn over the top card of the third pile. It holds an important message for you about your future with the tarot.

> ### Helpful Hint
> If any alarming cards appear, especially in that third pile, *do not be afraid*. In this reading, these cards show messages about obstacles you will face in your journey. Knowing about these challeneges will aid you in overcoming them. Take courage.

Record the reading in your journal and gather your cards together in a single stack, placing them over your heart. Breathe deeply and once again feel your heartbeat vibrating through the cards and into your hand. Give thanks to the deck for any insights you have received.

Any time you are ready to begin a new reading you may perform a miniature form of this ritual by placing the cards over your own heart, feeling its beat with your hand, and stating a prayer of purpose. Until you find the one that will work best for you, I gift you mine to use: "Open my eyes that I might see, open my heart that I might understand."

Chapter 6
TAROT SPREADS

PLEASE, FOR THE LOVE OF ALL THAT IS GOOD AND HOLY, use spreads when you read the tarot! You will greatly reduce your confusion when working with the cards.

A tarot spread is the special order the cards are placed in for a reading. Each position tells the reader how the energy of that card is appearing in the querent's life and will help them interpret the card. For a truly masterful examination of the subject, you will want to read *Tarot Spreads: Layouts & Techniques to Empower Your Readings* by Barbara Moore, but here I will provide you with my favorite spreads to get you started.

THE DAILY DRAW

This is more of a technique than a spread. Each morning, ask your deck, "What do I need to be aware of today?" Pull a single card and consider it as having a message about what opportunities your day may bring and how you might best meet any

challenges. Some readers keep a chart of their daily draws for a month so that they can notice what patterns they are experiencing.

THE FOUR CARD SPREAD

```
[ 1 ] [ 2 ] [ 3 ]

   [ 4 ]
```

Tarot readers swear by their three card spreads and there are many of them to choose from, but I prefer this variation. Begin with a question like "What should I be aware of about _____?"

1. The Present Situation: Where do things currently stand?
2. Next: What is the current trajectory of this situation?
3. After That: What is the most likely outcome of this situation?
4. Recommended Action: What can you do to influence this situation for your greatest and highest good?

The Horseshoe Spread

```
  1           SIG.              7
     2                       6
        3     4     5
```

This functions very similarly to the Four Card Spread and is helpful when you would like a bit more information.

- Significator: Represents the querent in the reading. I prefer to draw this card at random instead of pre-selecting it.

1. The Past: What actions or events have brought you to this situation?
2. The Present: What is taking place that you should be aware of?
3. The Future: What is the current trajectory of this situation?
4. Action: What can you do to influence this situation for your greatest and highest good?
5. Environment: This indicates external forces that are impacting the situation and the general climate.
6. Challenge: This represents something (internal or external) that must be overcome. It is the greatest obstacle to your success.
7. Outcome: This represents the ultimate resolution of this situation.

If you find that you are upset by the outcome of this reading, focus intently on cards 4 and 6. These show the principal conflict and your best strategy to improve this situation and could be the keys to changing your situation for the better.

The Crossroads Spread

Path A Path B

SIG.

This is an excellent spread to make use of when you must make a choice. Common examples include "Should I stay, or should I go?" and "Will I prefer X or Y?" Designate one choice as Path A and the other choice as Path B.

First shuffle and cut to find your significator. Then, considering Path A, shuffle, cut and place cards 1, 2, and 3. Next, consider Path B, shuffle, cut and place cards 4, 5, and 6.

- Significator: Represents the querent in the reading. I prefer to draw this card at random instead of pre-selecting it.
- Cards 1 to 3: This line indicates what will follow if you select this path.

- Cards 4 to 6: This line indicates what will follow if you select this path.

Consider both paths and, most importantly, think about what would appeal most to the significator, especially when reading for someone else. An adventurous significator (the Two of Wands for example) will be interested in a more exciting and riskier path than something more stable (the Eight of Pentacles for example).

Advanced technique: To help reduce bias, write the names of the two paths on pieces of paper, fold them, and mix them until you don't know which is which and place them on either side of the table. Perform the reading and then after you have determined which path is more appealing, unfold the paper to see which was indicated. You may be astonished by which path you ultimately prefer.

Between Heaven and Hell

1

2

3

As noted earlier, the modern vampire hero often finds themselves trapped between powerful opposing forces. While they may face supernatural enemies, many of the greatest conflicts are internal, being pulled between diverging desires. For this spread, shuffle the cards and fan them out in a line. Now, rub your palms together vigorously until you feel them get very hot. Wave your nondominant hand (if you are right-handed, this will be your left hand) slowly over the cards and feel which ones seem to draw your hand down or lift it up. Continue to scan the cards until you arrive at three in particular: one that causes your hand to feel like it is floating higher (1), one that causes your hand to waver up and down slightly (2), and one that seems to pull your hand down toward it heavily (3). Take your time, rubbing your hands together again if you feel you need a recharge.

- Card 1—The Heavens: This is a message from your higher self and represents steps that can be taken for personal growth. This may represent your loftiest ideals and guiding principles.
- Card 2—Humanity: This represents your everyday thoughts and emotions and what your chief focus is in the real world.
- Card 3—The Netherworld: This represents the hidden world of the subconscious as well as your more base and visceral desires (see more about shadow readings in the next section).

These three cards show a simple map of your soul at the present moment. Notice where the desires of the three "selves" seem to be in conflict. Consider what actions you can take to help fulfill the aims of cards 1 and 2 as well as how to alleviate the influence of card 3.

Shadow Work

The shadow, according to analytical psychology, is a projection of the unconscious parts of ourselves that the ego (our conscious mind) does not identify with.

To give a very simple example, if you were taught from a young age that being excessively proud of yourself was socially unacceptable, you would learn to repress any feelings of pride and tuck them away where they couldn't be seen. If you felt that pride swell within you, it might cause shame and so you would learn to numb yourself to that sensation until it was lost to you.

Meanwhile, you would likely have a strong reaction to anyone who openly exhibited personal pride. You might see it as unspeakable arrogance and develop visceral (possibly even physical) negative reactions to these people. By engaging in "shadow work," you might learn to uncover this repressed aspect and finally allow yourself to feel the warmth of self-respect, confidence, and self-esteem that accompany taking pride in your own accomplishments. You would then, in turn, no longer have such a charged reaction to someone who was openly proud.

Shadow work is a complex process that will involve a great deal of self-reflection as you unpack the contents of your subconscious mind. This simple technique is designed to give you a place to begin this study. First, look through the cards one at a time and set aside one that gives you a powerful negative reaction. This goes beyond simply not wanting to experience what is happening in the image and represents what you think is wrong with the world today. Don't be surprised if a traditionally "positive" card is what is upsetting you, this is common.

Spend a few moments looking at the card. Consider people in your life that remind you of the qualities of the image that you

find revolting (perhaps a public figure you greatly dislike). See if you can remember times when you acted in the way indicated by this card and what happened to you as a result (perhaps as a child you were scolded, shamed, or otherwise discouraged).

Now, consider what the greatest gift of this card might be. What do people who exhibit these traits seem to enjoy about their lives? Now state clearly, "I give myself permission to _____," and speak about all the ways that you would embrace the energy of this card. If you were focusing on the Emperor, for example, it might include, "I give myself permission to take charge. I am going to tell people what to do and I am not going to listen to any complaints or excuses. I am going to keep pushing until I get my way." Let it all out. Afterward, consider how you feel. You may discover that you still find this card revolting, in which case it is not likely to be a shadow that you have repressed. But if you did find that you felt empowered by your statement, this may indicate that you have some work to do in this area. Consider a few healthy ways you could begin to integrate this card's energy into your life.

Chapter 7
A GRIMOIRE OF MEANINGS

WE COME, AT LAST, TO THE HEART OF THIS CODEX: A GUIDE to the individual meanings of each tarot card. As was discussed in chapter 3, there is no one true, original meaning for any tarot card; however, various schools of tarot have cultivated sets of interpretations for each card and those have been passed down over the years as new decks have been created.

This section will tell you about the unique energy of each card. When you understand the vibe of a particular card, you can apply that vibe to the position it occupies in your reading.

For each card, the particular meanings that the author and illustrator intended for this deck are described. This begins with a description of the scene depicted on the card and the iconic vampire symbolism and mythology that has been selected for it. This is followed by a thorough explanation of the divinatory meanings attached to the card, and for the minor arcana this includes the unique way that the energy of the suits and numbers combine to form its meaning. This

section ends with a suggestion for the interpretation of a reversed card, though, as was discussed in chapter 5, you may take a different approach to the reversed meanings of the cards.

These descriptions and interpretations are meant to serve as a beginning to your understanding of the cards, and your vast storehouse of meanings and associations will grow over time.

The
MAJOR ARCANA

As the suit that sets the tarot apart from other forms of playing cards, the major arcana has a special prominence. These cards signify powerful opportunities for transformation and personal evolution. The major arcana cards are not *better* than the minor arcana, but they do tend to be more dramatic. Where the minor arcana cards point to actions and activities as well as personalities in the court cards, the majors speak of the more mythical moments in our lives.

In this deck, several of the major arcana cards tell the story of a young mortal woman who finds herself caught up in the shadowy world of the vampires. Other cards in the suit depict heroes, villains, and other dynamic characters among the undead.

A common practice for readers is to begin by counting the number of major arcana cards that appear in a spread. The more that turn up, the more… intense the querent's life is likely to be at this time.

0 – The Fool

A young woman out for an evening stroll has a chance encounter with an intriguing stranger. He offers her a blood red rose and an evening of unusual adventures. She hesitates for a moment, considering whether she will accept.

The Fool is the card of the innocent, one whose naïveté allows them to consider choices that a wiser soul would flee from. In myth, it is the foolish and inexperienced young person who begins the hero's journey when they accept a call to adventure. In fact, the arc of the major arcana has long been called "The Fool's Journey."

This card indicates the start of a transformative exploration. It asks us to enthusiastically say "Yes!" to life and all its unknown possibilities. It reminds us that we have much to learn about the world and that to learn more requires seeking out direct experience.

The Fool recommends accepting a diversion to our plan. Zag instead of zigging. Listen to your instincts and be open to unexpected options. This is an auspicious card for anyone who feels they need to change things up. Above all, have fun. Fools tend to travel light. They act now, when the moment is right, rather than packing and preparing for unforeseen obstacles.

Reversed, this card warns of foolishness and unhealthy risks. What seems like a bit of fun is likely recklessness. The reversed Fool says we should ignore the tantalizing diversion, and instead act prudently. Choose safety and certainty.

I–The Magician

In a cluttered study, a vampire magus carefully performs a ritual. In accordance with his will, a stream of blood floats up from a slash on his wrist, twisting in the air to form a lemniscate, the symbol of eternity. On his worktable are the mystical tools with which he can control the four elements.

The Magician is a master manipulator in every sense of the word. By his art, he channels the divine energies of the above to create changes below. Creating these changes requires a clear vision. See yourself achieving success in your mind's eye. If you can imagine and believe in the vision, you can bring it to life.

This card signifies the expert use of talents and skills. The Magician makes things look easy, but working wonders is hard, requiring focus to keep all the elements in balance. Have confidence in your abilities and use all the resources at your disposal. You are prepared for this project, and it is time to begin. As your efforts take shape, remain in control, and carefully bring your dreams into reality in accordance with your will.

This card also rewards originality, innovation, and cleverness. You are meant to create something unique. Be bold and release attachment to other people's opinions.

When reversed, the Magician is the divine trickster, deceiving his audience with stage magic and sleight of hand. This card reversed signifies a person achieving their goals through charisma and dazzling a credulous audience. In a word: showmanship.

II—The High Priestess

Before the veil of mysteries, a vampire priestess conjures visions of the sun and moon. In her hands are two hearts: one ignited by the sun's gold rays and the other illuminated by the moon's silver glow. She offers initiation to be purified by the scorching light of day and renewed with the healing darkness of night.

The High Priestess, ultimate symbol of intuition, sees both what is visible with mortal eyes and that which is hidden within. From these combined pools of understanding she draws forth the truth. Omens and flashes of insight may be coming to you—don't brush them aside. Listen to your inner voice.

As the keeper of secrets and veiled knowledge, her appearance signals that there are factors that cannot be known or understood in the usual way. You must, as was required at the Oracle of Delphi, "Know thyself" before you can discover the hidden truth. She also points to secrets in general.

Answers may be found within the subconscious. Calming yourself and meditating will help you explore these hidden depths with discernment. Take time to relax as you consider what you believe to be true. Honestly observe and distinguish between your automatic reactions and illusions, and the hidden jewels of truth.

Reversed, the inner eye is closed, and we should be cautious about trusting our own beliefs. Frustrating as it may be, in this orientation the card can indicate that the desired information cannot be known at present or that the way before you is barred. It can also indicate that secrets are being kept from you.

III—The Empress

Legend has it that when Lilith was cast out of Eden, she found new powers in a secret place and became the eternal mother of all creatures of the night. Vampires believe she is the first of their kind and offers her protection to them, her most precious children.

The Empress exudes kind and nurturing energy. This is a card of comfort and gentle healing. You may need some serious self-care in whatever form brings you the most pleasure. Like an oasis in a harsh desert, self-care rejuvenates us and heals our wounds and scars. This is no time for self-denial or restraint. Be kind to yourself. Take it easy.

This is also a powerful symbol of fertility. The time is ripe for conceiving an important endeavor. The ground has been made ready and what you plant will grow healthy and strong.

The Empress is also a card of great abundance that recommends we recognize the lushness and joys of life. With appreciation and gratitude for these blessings, we can share them with those around us.

On occasion, the maternal aspect of this card is more literal, and we may be called to connect with mother figures in our lives and our own nurturing impulses. It is an auspicious card for anyone wishing to become a mother.

Reversed, her mothering energy becomes smothering. Self-care can become self-indulgence. It is time to refocus and move with purpose.

IV – The Emperor

As the ashes of his predecessor float around him, the new vampire prince takes up the symbols of his office: the scepter that affirms his power to rule and the orb that connotes the vampires' reign over the earth. Power among the immortals must be claimed and then defended against competitors. The prince is dead, long live the prince!

The Emperor epitomizes the rule of law. There are structures in place, and they should be respected. His is a tough love that pushes us to be serious and disciplined. This is a card of leadership, signaling an opportunity to assume a role of prominence. It reminds us that, like a benevolent patriarch, to be worthy of command we must hold ourselves to a high standard.

This card also reminds us of the benefits of ambition. We can do better than "good enough." To improve your efforts requires a cool head and deference to logic over emotion and personal preference.

On occasion, the paternal aspect of this card is more literal, and we may be called to connect with father figures in our lives and our own paternal and protective impulses. It is an auspicious card for anyone wishing to become a father.

Reversed, he seeks power for its own sake. In this orientation, the card suggests ruthlessness, abuse of authority, even cruelty. Don't be too demanding; become too rigid and you will snap.

GRATA SINT OMNIA

V–The Hierophant

Outside a grand church, a statue of the Blessed Virgin guards the door. Before her are many offerings made by the faithful. A vase of roses and lilies indicates that she has devotees among mortals and immortals alike. The open door welcomes all wayfarers.

The word *hierophant* means "one who shows the sacred." Their solemn duty is to reveal the wisdom of their faith and preserve its traditions and institutions. They stand for taking the tried-and-true path.

This card also symbolizes the benefits of education. When it appears, there is much to learn about the subject of the reading, and we would be wise to defer to experts. Fill yourself up with established knowledge so you can form the best possible strategy.

The Hierophant may urge you to seek out a mentor who can help you develop your skills and understanding. It may also indicate that you are called upon to guide others.

This card reminds us to live in alignment with our core principles and values. Just as the statue crushes the symbol of the Deceiver beneath her foot, you may be called to speak the truth.

Reversed, the wisdom of this card becomes dogmatic and out of touch with the realities people face. In this case, it is a sign that you may need to cast aside the old ways and replace them with something more fresh and vital.

VI—The Lovers

Feelings have deepened for the unlikely couple we first saw on the Fool's card. In the shadowy graveyard, the mortal pricks her hand with the thorns of a rose and offers up her blood to her companion. This time it is he who hesitates as he considers whether to satisfy the hunger he feels. An ominous marble angel spreads its wings above the pair.

The Lovers card speaks of a turning point, a crossroads. When asked to decide which path to follow, this card urges you to follow your heart.

This is a very auspicious card for relationships and partnerships of all kinds. It shows that harmony and connection are possible. It indicates that feelings of affection are genuine and can be trusted.

It also reminds us of the benefits of unity. When we come together or form an alliance, we create something much greater than the sum of their parts. Life is too hard to do everything by ourselves.

Unity of this kind is best achieved when we are open, gracious, and charitable. Both parties will need to give and take so the relationship can flourish. This a good time to be at ease and let go of little imperfections.

Reversed, there is discord between the lovers. In this case it would be best to pull away from others and keep our own counsel. A partnership may sour if changes aren't made to its current trajectory.

VII–The Chariot

Amid the hedonistic celebrations of Mardi Gras, a vampire luxuriates upon a float pulled by figures dressed as Comedy and Tragedy. Crowds shower her with applause, and she revels in their adulation with fangs bared and claws extended. They see what she wants them to see. Let the good times roll!

The Chariot is a card of victory and forward movement. It shows an outer mastery as we overcome obstacles and achieve what we set out to do.

To achieve such success, we must suppress internal squabbles and conflict. Bringing opposing forces together, like the mortals who pull the chariot, will fuel you and propel you forward.

The Chariot's energy can be quite assertive, pushing against others' boundaries. This can be a sign not to accept the limitations people try to set for us. Only one person gets to be in the driver's seat and at present this should be you.

The Chariot asks us what we hope to find over the horizon. It advises boldness and courage in pursuit of our goals. Muster the drive and determination to rise above your present circumstances, and you can conquer the unknown.

In a reading, the Chariot can also signify travel and vehicles.

Reversed, the wheels of the Chariot spin wildly. There's no forward motion. The reversed card's energy is focused on the driver's ego. What was assertive devolves into mere aggression.

VIII–STRENGTH

A vampire's greatest adversary is the voracious call of their own hunger. Within their immortal body resides a beast who ceaselessly demands that they feed on the blood of the living. If this hunger cannot be mastered, a vampire will be revealed as a raging, insatiable monster, hunted down and destroyed.

Strength reminds us that to have control in our outer lives, we must first learn to control ourselves.

There is a significant difference between seeking power over others and power from within. Power within is how we understand ourselves and our desires and lets us manage our lives with discipline and self-respect.

This is a card of great fortitude. People have proved time and again that we can overcome adversity with own grit and determination. You may be called upon to endure hardship. This card suggests that you will persevere.

When this card appears, we should consider our inner saboteur, the voice of doubt that tries to trip us up. Determine whether any actions you are considering are self-destructive.

Strength calls us to be gentle but firm with others in conflict. We teach others how to treat us, and when we don't take the bait or react with anger, we communicate that they should adjust their approach.

Reversed, the inner beast proves too strong. It would be wise to ask for help and open up to someone you can trust about your struggles.

IX – The Hermit

Perched on a bleak and lonesome gargoyle, a vampire writes in a leather journal. High above the city, isolated from the hustle and bustle, the noises and the crowds, he has all the time he needs to spend with his thoughts. Vampires' lack of mortals' mundane cares and concerns gives them infinite time to consider weightier matters. With lives that stretch out across eons, vampires' journals chronicle the wisdom of the ages.

The Hermit speaks of our desire to seek out the truth by stepping back from the busyness and complexities of our day so we can look within for answers to life's persistent questions. This card is auspicious for those wishing to follow their own true path in solitude.

You may benefit from keeping your own journal in order to set down and reflect on your thoughts. Taking time to record and ponder your thoughts and observations may bring new appreciation of our experiences, inspire insight, and deepen your understanding.

The ascetic Hermit reminds us to keep things simple. When this card appears, it is a good idea to release attachment to the nonessentials. Travel light so your soul can soar.

Reversed, it's time for the Hermit to come down from his perch near the stars and rejoin the waking world. Too much introspection and too little social connection leads to self-absorption, confusion, and loneliness. We are social creatures, and our well-being requires connecting in meaningful relationships. The reversed Hermit says you will benefit by contact with others.

X – The Wheel of Fortune

An ancient book of lore depicts one of the most primal cycles known to our world: that of the predator and its prey. The image illustrates an inconvenient truth: life revolves and circles in interconnected cycles and there are greater powers overseeing these cycles.

The Wheel of Fortune reminds us that what goes up must come down—and will one day go up again. When this card appears, it signals that forces beyond your control affect your situation.

Luck is a very real force in the world. We can prepare to the best of our abilities, but some things are out of our control. If the card is upright, you are the wolf, the seeker, the hunter, the active agent, and your luck will be good. Take a chance.

This is also a card of seasons and cycles. Upright, it suggests that a new cycle is beginning. This is an auspicious time for expansive plans and projects. It suggests leaning into the new and exciting.

Reversed, you are the hare, a subject of chance, moved by forces outside your control. Luck is not likely to be on your side and it is wise to move carefully and cautiously. Protect yourself and those you love. Have a backup plan. This is also the sign of a cycle ending. With grace, try to see that it ends as best as it can.

XI – Justice

In a secret dojo, a mortal vampire hunter trains their mind and body for their difficult nightly battles with the undead. The nosferatu are notorious tricksters, using shadows and illusions to mystify the mind. For this reason, hunters must train in the art of blind fighting. They must let the wisdom of their other senses guide them in combat.

Justice is a card of cause and effect. We can only get what we deserve—what is our due—if we invest time and energy into an endeavor. When this card appears, ask yourself if you have done everything that you can to achieve your goals. Justice does not play favorites. It does not reward people for their inherent goodness, only their achievements and actions. This is the meaning of just rewards.

Justice is a card of truth. It may foretell an upcoming revelation, a hidden truth revealed. It can indicate an important breakthrough in your understanding after careful study and consideration.

This card also points to issues of justice and righteousness. We may be urged to lend our strength to causes that we believe in deeply, especially those that will bring greater equity to others. Choose your allies wisely; do not accept half-truths; do not support unjust causes.

This card is traditionally and obviously associated with legal dealings and arbitration. Upright it is likely favorable; reversed less so.

Reversed, this card rather handily points to injustices. In this orientation, it suggests that your efforts will not be recognized or rewarded as they should be. Sometimes life is not fair.

XII–The Hanged Man

Legends speak of ancient vampires' ability to enter a state of intentional hibernation. Their bodies desiccated when they didn't feed on human blood, but their minds and souls are freed to wander unseen roads where dark secrets and hidden powers will be revealed to them.

The Hanged Man presages a period of inaction, a time when we must step back and allow events to change and shift without our participation. This card touches on issues of vulnerability and uncertainty. It is natural to want to react to events, but you would do well to withdraw and wait.

This card advocates passivity and withdrawal from the present situation. Let go, release attachment to desired outcomes, and use this time to turn inward. Wait for a moment when you are stronger and more centered. In matters of conflict, this card clearly states: walk away.

This card can also be a message about the need for rest or a period of withdrawal, possibly on a sabbatical. You benefit from disengaging.

The inverted position of the Hanged Man also speaks of changing your perspective. Try to see things from a completely different and more expansive point of view. In this way, we can keep our ego from always running the show and avoid issues caused by tunnel vision.

When the card is reversed, the waiting period is over. To linger any longer will just cause unnecessary delay. With energy and spirits restored, it is time to rouse yourself and get back in the action.

XIII–DEATH

The young woman lies prone. Her lifeblood has all but left her, and soon her heart will cease to beat. But poised above her lips, her vampire companion offers precious drops of his own eldritch blood. Contained within this vital fluid is the magic that will usher her into a new existence. The ultimate transformation: out of death comes new life.

Death is a card of endings and loss. It shows doors that must close so that others can open. And it reflects fear and anxiety associated with such important life changes.

This is a controversial card because of its use in horror films. Death (like all other cards) is symbolic, and its appearance is unlikely to mean someone is about to die. That said, the change it points to is often a very profound and difficult experience.

This card can be the herald of transformation. When a caterpillar is enclosed within its cocoon, it releases enzymes that dissolve its body almost entirely. Only then can it emerge in its new form. It must be annihilated to earn its wings as a butterfly.

This can be a card of sacrifice. Often when we seek a significant change in our lives, something must be discarded to make room for new growth. Some aspect of the situation must end so there can be a new beginning.

Reversed, this becomes a card of stagnation. Things are not allowed to end, and time stops. Alternatively, this can be an indication that some life remains that can be kindled.

XIV – Temperance

Not every vampire delights in the endless cycle of feeding and carnage. This one has studied the esoteric arts of alchemy. Blending the essence of lilies and pure water with blood reduces her hunger and the need to hunt and feed.

Temperance is a card of mixing and blending to find just the right formula for balance and equanimity. Temperance depicts seeking and achieving a truly transcendent equilibrium. We might find ourselves "in the zone." In this state of flow, life seems effortless because our level of effort is just right.

Attaining this rapturous state requires care and restraint. Tempered restraint does not mean holding back entirely or not participating. It means being and doing just enough. Giving just the right amount of energy to a situation allows it to progress and evolve in an appropriate, manageable way.

Begin by attending to your senses. See, hear, feel. When you have made a proper assessment, you discern what intervention is appropriate.

Temperance also speaks to the mysteries of alchemy. The fundamental metaphor of alchemy is purification, which is releasing that which no longer serves and attaining the purity. For humans, this is self-knowledge and wisdom that allow us to become all that we can be.

Reversed, this card reminds us that the saying "Everything in moderation" ends with "including moderation." A reversed Temperance card reflects letting loose and letting events unfold without imposing our intentions or trying to control them.

XV – The Devil

The young couple find themselves in the grasp of a powerful and ancient vampire lord. They drink greedily from his wrists, enraptured by the power of his blood. He rejoices in his victory, knowing that his blood enslaves them to his will.

The Devil is a card of darkness and domination. It depicts forces that have control over us and subvert our natural will. Perhaps it is a person trying to influence us, or an addiction or obsession that we cannot let go of. If you are not careful, you will find yourself in bondage to another's will or enslaved by your own desires.

Classically, the Devil is a sign of deception and unwise bargains. Be careful with the deals you make and take care if you are tempted to relinquish your power. Read the fine print and think twice, three times. It's probably best to walk away.

This is also a key card for shadow work. We may project onto others aspects of ourselves that make us uncomfortable or ashamed, condemning them for our own hidden sins. Our feelings of hatred and extreme revulsion may point to something that controls us, something we have hidden in our own psyches. Recognizing and acknowledging this aspect of ourselves is the first step to getting free. To cast off a spell, you must first know what it is.

Reversed, the Devil lightens considerably. Here the card speaks of chains falling away as we accept ourselves for who we are and enjoy hedonistic pleasures and delights. Here, the pleasure is pure and uncorrupted.

XVI – The Tower

It takes decades of careful planning for a vampire to craft a persona that allows them to move freely in human society. From constructing one's lair to finding the right minions, everything requires effort and consideration. And all of it can be lost in a single night of fire. The Tower depicts the moment when the game is up. A crowd of mortals has gathered around a manor house, bent on its destruction. The lower levels are already in flames. Anyone inside would do well to escape before everything comes crashing down.

The Tower is a card of chaos and upheaval. It speaks of the moments in life when, seemingly without warning, the rug is pulled out from under us, and we must react quickly to salvage what we can.

When this card appears, things tend to get rocky; structures we relied on fail and systems break down. It's hard to "expect the unexpected," but if the Tower turns up in a reading, it is a sign that we should create a contingency plan.

The Tower asks us to make ready for a bumpy road ahead, unexpected turbulence in a relationship, or an inconvenient mishap. The status quo will be upset. Be prepared. The degree of all this can be reduced if we respond rationally instead of reacting with heightened emotions in a moment of distress.

Reversed, this card speaks of a crisis averted. The reversed Tower depicts an opportunity to reorient oneself, avoiding the most difficult elements of an upset. It can also indicate being finally freed from a structure that had us trapped or caged.

XVII – THE STAR

A vampire's existence is more than an endless cycle of hunting, feeding, death, and darkness. There is also splendor, beauty, and rapture. Here a new vampire tests her blossoming powers, levitating above the world to swim in a sea of star. The bright star that shone down on Lilith bathes her in its light.

The Star is one of the most beautiful and uplifting cards in the tarot deck. The first of the "celestial" cards of the major arcana, the Star's light is faint but clear. It promises better things to come.

First and foremost, this card depicts hope. It is the bright light at the end of the tunnel that keeps us moving through the darkness.

The Star also indicates rest and healing of all kinds: physical, mental, emotional, and spiritual. If you are suffering in any way, prioritize your health and well-being. Seek guidance from specialists and give every part of you what it needs, including time to heal. This may be an ideal moment for energetic cleansing, which may include burning purifying herbs, bathing in saltwater, and deep breathing.

The Star can also turn up when someone is in a dark place and in need of kindness. Offer it freely if you are able. Accept kindnesses that are offered to you, as well.

Reversed, the light of the Star proves to be a false hope. It can appear in this way when we have been holding out for a miracle solution to materialize. In this case, do not despair. Seek a more practical solution instead.

XVIII–The Moon

Tales of the rusalka tell of a terrifying undead creature that disguises itself as a lovely maiden. With her captivating beauty, she lures victims into a river or lake and then drags them down to meet their end. A pity … but what a way to go.

The moon is a mysterious orb, and its card, fittingly, is the card of illusions. Shadows dance in the darkness when the moon is bright. In moonlight, our eyes play tricks on us. When this card turns up, it is very likely that things are not as they seem.

This card also suggests that fears and doubts may cloud your judgment. The moon rules the tides and may affect the ebb and flow of our emotions as well. In lore and folk wisdom, a full moon is known for strangeness, and on full moon nights we may feel especially vulnerable and ill at ease.

Under the Moon's influence, with distorted perception and strange emotional impulses, you may not be in a good frame of mind to make important decisions. To be certain you are on the right course, wait for additional clarity. Keep your eyes wide open and monitor your emotions to insure you can make wise, objective judgments.

Reversed, the Moon takes on quite a different meaning. Here it is the sign of the Mystic. It suggests that powerful psychic information is being received. You may perceive signs and see what others cannot. Take care, as this can be a difficult journey. But this mystical light will guide you.

XIX – The Sun

Pursued by a vampire, a mortal bursts through a window into the light of day. The undead creature claws at his fleeing prey but the sun burns his unholy flesh and sends him crawling back into the darkness.

The Sun is a wonderful card to find in your reading. It blesses you in whatever situation you find yourself and suggests that a satisfying conclusion is on the horizon. The light of this card brings clarity. Its warm glow melts our doubts and fears that have frozen us in immobility. If you have been waiting for a "yes" before you proceed on some undertaking, here it is. Your challenge is to accept the message, take yes for an answer, and turn your back on the comfort of your old doubts and reservations.

The sun's light is literally energizing and when its card appears we can expect to experience vitality and restoration.

In the warmth of the sun, plants grow and ripen until they are ready to be harvested and enjoyed. This card promises that things will develop and improve from the care and attention we give them. The Sun card presages success in your undertaking.

Reversed, the light of the sun dims only slightly. This is such a joyous card that not even a reversal can bring it down. The reversed Sun says, simply, this situation will be less than perfect but still very good. Do not pine for perfection. Accepting good things as they are gives you more time to enjoy them.

XX – Judgement

The tables have turned and the couple, with the unlikely assistance of the hunter, overthrows the dark lord. Once a meek creature, naïve and unsure of herself, the new vampire rises up and plunges a stake into the heart of her oppressor. With a scream, he is reduced to ash.

Some readers are put off by this card's name, fearing that it means they will be judged or are judgmental. Instead, it speaks of a final, cosmic judgment when all who have passed on find their eternal reward.

Judgement depicts a critical moment when we fully embrace and practice the lessons we have learned and wisdom we have gained. Be the change you wish to see in yourself.

This card suggests that you feel in your soul a purpose you long to fulfill. Like a snake, you must shed your old skin to be reborn, cutting ties with things from your old life that prevent you from fulfilling your true destiny. Leave behind untrue or unproductive old thought patterns and negative self-images. Many describe this feeling as waking up and finally feeling like they recognize themselves.

This card sometimes points to a final test that will be revealed if we have truly integrated the changes we longed for. You are ready to pass this test.

Reversed, the call goes unanswered. We are not yet ready to leave our old selves behind and must continue to prepare. Be patient; you will know when you are ready to shift into a new mode of living.

XXI – The World

High above the city streets, the fledgling vampire, whose journey we have followed, rejoices in her new life. In her hands are the lily of mortality and the rose of the immortals. She need not choose between them. She has retained the light of her humanity and become a protectress of her city, embracing the gifts and powers of her new form. She endured much to get to this place—transformed and joyous, fully alive and aware

The path through the tarot's major arcana culminates in the World. It symbolizes the completion of our transformation. This card is a sign that you are significantly changed and for the better, aware of your purpose and attuned to the flow of life through time.

Completing our journey, learning our lessons, knowing ourselves—all help us find our true place in this world and align us with the greater turning of the forces of the universe.

When we are so transformed, we are not the only ones who benefit. The last stage of the hero's journey is the return home. The hero's home community can grow and learn by sharing in their success. Change one thing and you change the world.

More simply, this is a card of victory and achievement. You accomplish what you set out to do. Don't hold back and don't look back until you cross the finish line.

Reversed, we fall short of our goal or find that our success rings hollow. Unfinished tasks can feel frustrating; they can linger in the psyche causing anxiety. Decide whether this goal is worth another try.

The Suit of
WANDS

THE SUIT OF WANDS IS ASSOCIATED WITH THE ELEment of fire. These cards represent energy, passion, boldness, spirituality, adventure, and ambition. They portray the spark of inspiration and the burnout of overloading ourselves.

More than anything else, the vampires in this deck hold sacred the potent vitality found in their blood. The wands are depicted as ankhs—the ancient Egyptian symbol for life. These ankh wands are used principally by mystically inclined vampires known as blood mages who can tap into their own vitae to create dazzling effects.

In a reading, wands often indicate the desires and motivations that burn within the querent and propel them toward their goals. They also point to the more heated parts of the psyche including determination, rage, and lust.

ACE OF WANDS

The ankh is an ancient and sacred symbol of life. Above all else, vampires worship and revere the eternal vitality gifted to them by the unearthly power that pumps through their veins. Some among their kind have mastered the art of tapping into these vibrant energies. Here one such blood mage aligns with her wand and the blood responds gladly, ready to do her will.

The passion and energy of the wands springs to life as the ones begin a new cycle. This is a card of raw power awakening within us and making us feel more alive than ever. Something exciting is about to begin.

The Ace of Wands asks us to let go of doubt and fear and to make bold new choices with brave determination. When it appears, it is like a volcano simmering inside of us, ready to burst forth with creative potential.

The wands suit governs our will, the combined power of our purpose and our desires. This card asks you to understand where you most want to direct your energy at this time in your life. You don't need the complete map, just the direction to head in as you begin the journey.

A door is opening in your life. Say yes to this new opportunity that will challenge you and help you to grow.

Reversed, the volcano remains dormant, and our vigor goes unspent. You may need a little more time to work up the courage to begin. This can be a sign of hesitation, blockages, or a need to delay action.

Two of Wands

At sunset, high above the city streets, a vampire steps out on a railing. As the wind whistles around him, he summons a pair of ethereal wings formed with the power of blood magic. If his power holds, he will soar through the skies. Should his power falter, he will plummet to the earth. Looking out from the heights, he pauses before he leaps, motivated by faith in the ancient power he has called forth.

Twos speak of a desire for the wands' passion and power. This card shows a heart yearning for adventure, a journey that will take you out of your comfort zone. It is easy to dream of faraway places and lofty goals while safe and secure at home; making these dreams into a reality requires us to risk pain, failure, and loss. This card urges you toward ambition. Rise up and be greater than before. Act as though you are already the person you want to be. If you wish to be brave or compassionate or organized, imagine what someone who exudes that trait would do, cross your fingers, and do it.

The Two of Wands also shows the value of careful planning and preparation. To embark on this flight, the vampire had to study and master the mystic arts that will carry him through the skies. Stepping outside of yourself is best done with a map in hand.

Reversed, the card suggests that the time is not ripe for any audacious moves. Something closer to home needs to be attended to or more preparation may be needed. Stay in your lane.

Three of Wands

In the dead of night, a vampire performs a secret ritual, known only to those who study the old blood magics. Her incense burner echoes the ancient Egyptian boat that ferried the sun on its journey through the underworld. By the power of her will, a mortal is drawn to her side, ensorcelled by a call he cannot name. Her lips part in pleasure at the success of her spell.

The passion of the wands is made manifest in the threes. With this card, we commit ourselves to the course of action we have begun, we stride forth boldly in the pursuit of our goals and follow through on our promises. Honor your ambitions, prepare properly, and maintain momentum. There is no turning back.

The Three of Wands also suggests that when you exercise your willpower to change your relationship with the external world, you may experience an excruciating waiting period before you know if your plans are successful. You have set things in motion; keep your enthusiasm high and believe in what you have chosen to manifest. This card is favorable to expansion of all kinds: new ventures, new personal explorations, and new ways of thinking. More is more.

Reversed, this card suggests that plans for expansion will be constrained and delays are to be expected. It may also indicate that you are holding yourself back with doubt and self-denial. Make sure your heart is in this. Things may not pan out as you desired.

Four of Wands

In a dancer's cage high above the crowds at a nightclub, a vampire moves her body to the beat. But it's not the blaring music that fills her ears, it's the pounding pulse of so much life all around her being pumped through such beautiful bodies. She revels in the perfect moment: she is eternal, and all of this is just for her.

The passion and energy of the wands suit is given stability and balance by the fours so that it can become a shared celebration. This card appears when it's time to take things to the next level. It is a blessing to major celebrations of all kinds: weddings, graduations, initiations, and all other moments worth commemorating. This is your moment. You have earned the freedom and the extra attention.

Life has its many ups and downs, but this card reminds us that from time to time we must let go of stress and perfectionism and have a good time. This means getting out of your head and getting out of your own way. Trust your instincts and keep moving. This card often appears when we are pushing past old boundaries and old identities and becoming something greater. It is essential to live in the now.

When this card is reversed, there's likely a problem at the party. Things may seem like they are going well and moving forward smoothly but beneath the surface you will find instability. Here, blowing off steam may, in fact, be escapist hedonism. Communicate clearly with others and look closely at your plans for flaws you may have missed.

Five of Wands

High on a rooftop, five vampires engage in combat. The joyful image on the billboard depicts a false reality of peace and contentment. To survive in their world of darkness, you must hone your martial talents to perfection and constantly test your mettle against others. The fighters demonstrate a high degree of skill, flourishing their weapons and flipping through the air.

The energy and passion of the wands meets the chaos of the fives resulting in contests and game playing. This card asks us to embrace competition and test our own plans and opinions in the marketplace of ideas. Challenge the peace and contentment of the group. That peace often masks complacency. This is a time to let go of comfort and shake things up. No pain, no gain, as these vampires will tell you.

The Five of Wands reminds us that we live in a competitive world where we cannot expect to be given everything we think we deserve. It also signals that our difficulties are opportunities to prove ourselves and our abilities.

This card can also indicate that someone is playing with you. You can take the bait and possibly beat them at their own game, or you can choose to not play into their hands.

Reversed, the chaos of this card proves to be an unproductive waste of energy. Rather than a path to new and interesting solutions, fights turn out to be time and energy-wasting petty squabbles. Look for a peaceful resolution that moves the group forward to stability and growth.

Six of Wands

A group of young vampires marches confidently through a neighborhood at night. At their sides, the mortal residents they encounter are impressed by the young ladies' fearlessness and style and cheer them on. The vampires' leader holds two ankh wands aloft, glowing with the stored power of her blood magic. Nothing will break their stride.

The adventurous nature of the wands is rejuvenated by the restorative power of the sixes, culminating in enthusiastic forward motion. This is a card of triumph and victory, presaging the achievement of goals that you have been working toward.

It is also a card of leadership. By sharing your vision with others and demonstrating your capability, you may earn their trust and galvanize them to follow you on your path. Your example will encourage them.

It is a card of rising up to meet your destiny and being recognized for your achievements. Don't shy away from these accolades, and don't hide from them by becoming small. Embrace greatness.

The Six of Wands is an auspicious card if you are considering any type of move. It encourages momentum and journeying beyond the horizon. Take the initiative to seek out faraway places and new experiences.

Reversed, this card suggests that your ambitions are not yet ready to be fulfilled. You may find yourself feeling like you have reached a plateau and struggle to break free of it. This is a time to follow rather than lead. It may also indicate the arrogance and hubris of leaders, weaknesses that can trip them up.

SEVEN OF WANDS

If a vampire wants to live a full and rewarding undead existence, they must learn to handle a torch-wielding mob. This vampire reacts to an attack by a force wielding magical ankh staffs, their bright flames licking the night air. With precision and grace, she vaults from her balcony, easily clearing the fire, unharmed by the attack.

The power and vitality of the wands are augmented by the adaptability of the sevens. This card calls for rising to meet a difficult challenge.

You may feel overwhelmed, as though you are alone and unaided in contending with insurmountable forces.

The Seven of Wands asks you to take a leap of faith—faith in yourself. While the situation may seem dire, you have the high ground. Your experience, passion, and determination will provide the fuel you need to launch yourself into action. You've got this. Visualize your success as clearly as you are able and hold that vision in your mind as you make your move.

This is also an opportunity to prove yourself to others. Present difficulties test you and allow you to show the world what you are truly made of. This card advises "Go big or go home." Your ambitions will not be achieved by playing it safe or waiting to be given permission to act.

Reversed, the forces stacked against you are too strong at present. Now is the time to cool off and conserve your strength for a more opportune moment.

Eight of Wands

A vampire leaps from a high vaulted window. His body crackles with magical lightning as he is transformed into a cloud of eight bats who dart off into the night sky. Nobody makes a dramatic exit quite like the undead.

The energy of the wands is deepened by the eights. Above all else, this is a card of swift motion. When it appears, things take off like a rocket and gather speed. The Eight of Wands directs us to pick up the pace and to not impede our progress with unnecessary doubt or delay. Get out of your head and get moving. This card can represent the feeling of being "in the zone" where choices become instinctual, and we move with flow, trusting each decision and action in turn, and swiftly moving on. You may be asked to make a series of rapid decisions. In this case, the endeavor, as a whole, is more important than the tiny details.

This card portends kicking things into high gear. Already charged situations can become more intense. Tempers can easily flare under this sort of pressure.

This is an auspicious card for travel, especially by air, and other forms of movement. A change of scenery is an easy and exciting way to get a fresh perspective.

Reversed, this card retains its suggestion of speed but asks us to bring things in for a landing. It is time to bring the current situation to a swift resolution so that something new can begin.

NINE OF WANDS

A mortal woman has barricaded herself inside a home using the vampires' own ankh staffs, reinforced with crucifixes, to bar the door. Bloody bandages tell the tale of the difficult battles she has fought to stay alive. The setting sun fills her with a new dread. It's going to be a long night.

The energy and drive of the wands reaches a peak with the culminating power of the nines. This is a card of fighting hard for what you believe in. It often appears when we must defend a position just a bit longer as our goal is almost within our reach. The Nine of Wands asks us to steel ourselves for approaching conflicts. This is a good indication that clear and firm boundaries must be set and maintained. Refuse to accept the negativity of people who strive only to tear others down.

It is also a reminder that you were made for such times as these and have the inner strength and resolve to achieve greatness. Remember what inspired you to follow this path and draw on that inner fire. The struggle is real, but the hustle is deep.

Be aware, however, that constantly striving for what is right can strain your psyche and your relationships. This card can appear when defense of righteous causes becomes defensiveness that can lead to miscommunications and misunderstandings.

Reversed, this card suggests giving up a fight that threatens to overwhelm us. It indicates that our firm resolve may really be unproductive obstinacy. Choose your battles wisely.

TEN OF WANDS

The seeker has found the object of his evening's adventures—possibly a romantic partner, a meal, or maybe even both. But the golden light of dawn spills out across the city, and he must make his way back to his high tower before the burning rays of the sun can reach him. His shapely burden weighs him down and it will take all his magical strength to stay aloft.

The passion and energy of the wands overextends when brought into resolution by the tens. This is a card of strenuous ordeals that burden us. Perhaps this is a task laid on you by others or (most likely) a sign you are taking on more than you are prepared for.

The Ten of Wands reminds us that journey's end is near, and we must not give up just yet. It suggests that more labor is required if we are to achieve our ambitions. In these moments, it would be wise to reject distractions that could pull our focus away from our task.

This card often appears when we take on new responsibilities in pursuit of growth and advancement. It reminds us that we only benefit from taking on added burdens if we can successfully cross the finish line.

Reversed, the added strains and obligations are just too much, and you would do well to carefully consider laying them down. While it is ethical to keep our commitments, it is foolish to let ourselves drown in them. Consider calling in support.

Page of Wands

A young apprentice blood mage reads a spell from an ancient grimoire. Her ankh wand flares to life, crackling with power that washes over her. Her free hand grips the book as she seeks to keep her concentration while maintaining the spell.

Pages embody curiosity and learning. Like students, they explore the many facets of the suit's element, growing along the way. The Page of Wands has an unparalleled zest for life and is fearless in the face of new challenges.

As a person, this card represents someone enthusiastic, daring, and capricious. The Page of Wands is quick to test their own abilities by trying new things. This page is attracted to things that are sparkly, eye-catching, and new. For them, variety is the spice of life.

The Page of Wands may represent a spark that has ignited within you. Something has caught your attention and you feel compelled to pursue it. Perhaps you feel called to learn a new skill or undertake a spiritual quest. Kindle the spark with knowledge. This page can feel fear in the face of the unknown but if there is something they want to try, they don't let fear hold them back. "What's the worst that can happen?" they may ask.

Sometimes this card is called "the messenger" and could indicate that you will soon receive a crucial piece of communication. With the card upright, the news is welcome and encouraging; when reversed, less so.

Reversed, the Page of Wands can easily discover they are out of their depths. Their passionate pursuit may quickly fade. The reversed page tends to be fickle, easily discarding things that don't hold their interest.

Knight of Wands

A captivating vampire musician sings into an ankh-shaped microphone as stage pyrotechnics blaze behind him. He pours all the sensual power of his dark gift into his song.

Knights have grown enough in their suit's element to go out in the world and test their skills. They are seekers and action-oriented. This knight is a bold adventurous sort, eager to experience new sights and pleasures.

As a person, this card represents someone original, brash, and self-assured. They move and act at an unpredictable pace, making for the horizon whenever an idea captures their attention.

When it comes to romance, this knight has a reputation for flings and short dalliances. It will take a lot of energy to hold their interest for a longer-term relationship.

This knight may push you toward taking a big risk. They are extra and they remind us that to be larger than life is a wonderful way to feel alive. Seize the day, and you will not regret what could have been.

This knight can bolster your spirits like no other. Their self-assuredness is exhilarating, and they can be especially encouraging to their friends, daring them to test the boundaries imposed by self and by society. This card might appear when you desperately need to come out of your shell.

Reversed, this knight's bright flame can burn out too quickly. When this happens, they are likely to be impatient and short-tempered. If they're not having a good day, no one is.

QUEEN OF WANDS

The Queen curls up on a lush couch accompanied by a pair of regal panthers. With her ankh scepter causally tucked by her side, she knows very well who is in charge here. Golden torchlight dances on her glittering jewels and sequined dress. Her warm smile invites you to come closer.

Queens have established an inner mastery of their suit's element. This familiarity makes their actions natural and instinctual, as symbolized by their animal companions. They have a strong influence on others. This queen is always the life of the party. As a person, this card represents someone dazzling, charismatic, and dramatic. Their personality is electrifying and infectious. They light up the room, lifting the spirits of all they meet.

The Queen of Wands lives by the motto "Go big or go home." Self-confidence and ambition are powerful tools. Fill yourself with the conviction that you belong and are valued. Talk to and look at people so they feel like they are the only person in the room.

This queen is adept at inspiring others with words. When this card appears, someone may need a boost to their confidence (that someone might be you). It also speaks of the benefits of an impressive social media presence (vampires adapt with the times).

Reversed, the queen's bon vivant nature may make them seem insincere and a bit of a showboat. They can be self-absorbed, demanding amusement and admiration. This card can indicate a need to prioritize substance over style in the situation being considered.

King of Wands

With his flashy suit and cocky smile, he may not seem like much of a threat all on his own. But with a snap of his fingers, the vampire lord brings his followers to life. They are legion and he kindles within them a burning desire to do his will.

The kings represent an outer mastery of the element of their suit. They have accumulated enough experience and power to command others in their field of expertise. This king is the consummate politician, skillfully inspiring others to believe that his goals are their goals.

As a person, this card represents someone magnetic, authoritative, and ostentatious. They may be a natural improviser, performing majestically when the spotlight is on them.

The King of Wands knows that one of the most effective ways to win people over is to get them excited. They seek to understand what others are passionate about and use that knowledge to motivate. When people feel that your goals and their goals are aligned, they will join your cause. Winning people's trust will win you their hearts and loyalty as well.

The king is a capable negotiator. Be bold in pushing for what you want and you are likely to get it. Focus on getting to "yes." They are often an achiever as well and this card may signal that this is the moment to pursue your most ambitious goals.

Reversed, the king's bravado can fail to win over the crowds. Tone it down. They may be blinded by ambition, desperate to win the approval of others. Without the admiration they crave, their passions fall flat. It's possible they are just trying too hard.

The Suit of
CUPS

The suit of cups is associated with the element of water. These cards represent emotions, art, relationships, inner reflection, dreams, and empathy. They portray the depths of love and the pain of loss.

Though monstrous by nature, vampires are renowned for their love of beauty, music, and artwork of all kinds. The chalices and other vessels are marked with the vesica piscis, concentric circles that represent worlds coming together in unity and hint at the mysteries of the Holy Grail. The vampires in this suit seek out connection to remind themselves of their human souls.

In a reading, cups cards may describe the querent's inner state, both those emotions that hover near the surface as well as the depths of the unconscious. These cards have quite a bit to say about how we are feeling about ourselves and others.

ACE OF CUPS

Legends speak of the vampires' ability to take on the strange forms of mist and fog when needed. And from out of the swirling depths, a hand reaches up clutching a chalice filled to the brim with life-giving blood. The cup is decorated with the vesica piscis, a symbol that suggests being at the center of several worlds (material, spiritual, emotional, and intellectual) and drawing strength from all of them. The chalice pours forth its bounty. Like the sacred Grail of legends, it cannot be emptied.

The emotional depths of the cups brim with new possibilities as the ace begins a new cycle. This card speaks of divine inspiration and giving birth to new creative pursuits. Something fulfilling is about to begin.

The Ace of Cups asks us to open ourselves up to creative flow and let our hearts take the lead when making decisions. It suggests we are pouring ourselves into something new. Like water, we must adapt to our new surroundings.

This is an auspicious card when relating to relationships of all kinds. In particular, it speaks of our ability to heal our hearts by filling ourselves up with the rejuvenating power of the love we receive from others and from ourselves. Let the waters wash away dirt and grime of the past and gaze in admiration at the beautiful being you see reflected in the mirror.

Reversed, the new beginning promised by this card is delayed. Some sadness may need to be put at ease before rebirth can take place.

Two of Cups

In an intimate setting, a mortal man offers his wrist to a vampire. Even though he is choosing to give willingly of himself, we can see the hesitation and concern on his face. The vampire places her hand over his wrist. The gesture that may be an attempt to soothe him, but as she feels his lifeblood pulse beneath his skin, her craving for it is clear. A candle flame burns brightly between them.

Twos speak of a desire for the suit's element; in the case of cups, it is a desire for connection. This card speaks of profound intimacy between people or groups. It also points to tensions that arise when we wish to open up further and to allow connection to deepen, while knowing this makes us vulnerable.

In a reading, this card indicates great potential for a healthy partnership, and very often romance. It also speaks of the need for balance and receptivity from both parties. They must be willing to meet as equals.

Like many cards in this suit, the Two of Cups also asks you to think with your heart rather than your head. There are significant hurdles for a vampire and mortal couple, but imagine what they can accomplish together.

It also speaks of our desire to be seen and to be heard.

Reversed, this card suggests disharmony between two parties. Secrets are withheld, goals are not shared, and it will take much work to see eye to eye.

Three of Cups

On a warm summer night, the sky aglow with strings of lights and the stars above, three lovely vampires float in the air, clinking their glasses together in a celebratory toast. A carnival has been laid out before a stately manor house with brightly colored tents and a spinning Ferris wheel. Soon it will be filled with crowds of mortals who can surely provide these ladies with an array of delights and diversions to sate their appetites. (Un)Life can be so sweet.

The emotional depth of the cups is made manifest in the three and the result is pure pleasure. This card heralds a coming harvest and suggests that a celebration is called for, with gratitude for things just as they are. It is a card of felicity and gentle connection with friends and loved ones, and of doing what feels good right now and letting that be enough. This is an ideal time to reach out to plan a party, vacation, or a night on the town you will never forget.

This card is also auspicious for creative pursuits. New ideas come bubbling forth and they should be explored without the constraints of excessive logic and too many rules.

Reversed, this card calls to mind the phrase "too much of a good thing." Levity might need to be replaced with seriousness. This can also suggest something unpleasant is surfacing in your circle and may need to be addressed, or that some time alone would be beneficial.

Four of Cups

A vampire kneels before a mini fridge filled with chilled bags of plasma. By restricting his diet to the frozen section, he has remained safe and secure. But a breeze through his open window seems to call him forth into the night to hunt for something fresh.

Fours create stability, and when it comes to the emotional and creative cups, that stability can become stifling and confining. The Four of Cups signals dissatisfaction with our situation. What used to enliven us is now a boring source of drudgery.

The card also suggests awareness that something is missing. Things seem perfectly pleasant on the outside, but beneath the surface you may feel you will go stir crazy if you don't find that last essential piece that will lead to wholeness. Look inward and outward and identify the area that is out of alignment, then go find what your heart most longs for. Often when this card appears, what you most desire is closer than you think. Change things up a bit, find the thing you really crave, and free yourself from monotonous routines.

When reversed, the card is quite comfortable and cozy. In this case, it's best to begin with gratitude, identifying your many blessings and giving thanks in appreciation of them. Doing this can allow you to see your life with fresh eyes and a new appreciation for all that you have. Stay put and don't answer the siren's song that wants to lead you astray.

Five of Cups

A vampire visits the graves of her departed loved ones. Her new life took her out of their orbit and now it's too late for any connection with them. Three urns of lilies, the symbol of mortal purity, have been dashed to the ground in sorrow. Two undead companions bear urns of roses, the symbol of eternal life. When you live forever, you must learn to let go of impermanent things.

The emotional depth of the cups is shaken up by the chaos of the fives. This is a card of loss and disappointment. We must accept that despite our deepest wishes, we cannot have all that we want. Pain is part of life.

Feeling unfulfilled can cause all sorts of difficult emotions like shame, resentment, and grief to well up. This card indicates a need to properly mourn our losses and make peace with grief. It also urges us to learn from past mistakes, to truly understand what went wrong so that we can make more fulfilling choices in the future. Take the time you need to fully release what is being held inside.

This card can also suggest you've invested emotionally in a particular outcome and may be disheartened by failure or even a partial success.

Reversed, the focus shifts from the spilled urns to the two upright ones. In this case, the mourning itself may be what is holding us back and barring us from seeing the many opportunities around us. It is a call to spend no more time on the dead and embrace the living.

Six of Cups

In a sun-drenched kitchen, a doting father pours his daughter a bowl of her favorite cereal. A cartoon vampire grins on the front of the box. The day is bright, and the sun shines down on a world in which monsters are merely fantasies and there is nothing to be afraid of.

The healing power of the sixes blends with the emotional depth of the cups to form a scene of absolute serenity. This is a card of sweetness and lightness, soothing our worries and doubts and simplifying our situation. Try to have some fun.

The Six of Cups asks you to remember an easier time when life was filled with hope and cheer. We are called to remember ourselves as we were and how we wanted the world to be. Find the truth in the best parts of the past. See the best in other people and in yourself. This card also urges us to take it easy, take a load off and take a break. Balance work with play so that joy can enter into anything you create.

We are also encouraged to bring joy to others. Tenderness and affection shared with an open heart will bring ease and comfort to the both of you. This may be a moment to defer to another's position and focus on their needs.

Reversed, this card's nostalgia proves to be naïveté that blinds us to the real problems we must face. There are monsters in the world and wishing it wasn't so doesn't make them go away. It is best to take a more skeptical view of the matter at hand.

SEVEN OF CUPS

A vampire in an elaborate ball gown stands before seven niches that each contain an urn adorned with a mask. Who will she be for this evening's festivities? An angel? A queen? A dragon? A skeleton? A jester? A devil? The moon? As soon as she makes her selection, she may join the dance.

The emotional depth of the cups is given new flow by the adaptability of the sevens, resulting in expanded horizons and flights of fantasy. It asks you, "Who do you want to be?" and "What do you want to do next?" Set aside stark reality and dare to dream for a moment of bigger, better, and more interesting choices. This is the gentlest of the "change" cards, suggesting that you have time to explore your options and check in with yourself about whether a choice truly feels fulfilling to you. This is a time to dabble, let your imagination and creativity pull you where they will until something clicks into place.

The Seven of Cups is also a card of illusions. Its appearance in a spread suggests people and situations may not be quite how they seem. It advises that we take the time to discern what is real and what is false about the choices being offered to us.

Reversed, this card suggests that you may have lost your way by daydreaming and dawdling. Focus your attention and efforts on a clear, sensible path and move forward. This will ensure you don't waste your time in limbo.

Eight of Cups

As a mortal, she prized her beauty above all else. It was why she chose the cold life of a vampire—to preserve her allure forever. Alas, she did not know of the curse shared by some species of the undead that hides their reflections forever. Her previous life path no longer holds anything for her, and since she can no longer perceive her own beauty, she will need to find a new way to see beauty in the world.

The emotional awareness of the cups is deepened by the eights. This is a card of reevaluation, reconsideration, and adjustment. It often appears when we are feeling alienated from the journey we have set ourselves upon. This is often accompanied by a sense of guilt about giving up, sunk-cost fallacies, and a belief that to turn aside is failure.

The Eight of Cups asks us to consider what we truly desire for ourselves in the present moment. What recalibrations will help us best address these desires? This is a call for inner acceptance and suggests you have the courage to pursue a more suitable path. Time is precious and it must not be wasted by following roads intended for someone else.

This card can also appear when we are aware of a growing distance between ourselves and the people and things we once loved; parting ways consciously and with gratitude may ease this transition.

Reversed, the path still holds something for you and the time is not right to abandon it. There are struggles but you're just a little bit closer than you were yesterday.

Nine of Cups

The legends of Elizabeth Bathory speak of the infamous Blood Countess, kept unnaturally young and beautiful by bathing in the blood of virgins. Here we see her sinking into bliss as her skin and hair are made more lustrous by the generous application of hemoglobin. Raising her goblet in the air, she toasts a long life well-lived.

The emotional depth of the cups overflows when paired with the culminating power of the nines. This is a joyous card that speaks of pleasure and fulfillment. When it appears in a reading, things are certain to improve.

Nothing succeeds like excess and the Nine of Cups gives you permission to let loose with wild abandon. Treat yourself to what you want, pull out all the stops and go big. Your own satisfaction is crucial at this time.

This has often been called the "wish" card, encouraging the querent to dream big and to believe that these dreams will be fulfilled.

There is also an element of gratitude indicated by the card, suggesting that you consider the many blessings in your life and that you make good use of them at every opportunity. It also encourages us not to sweat about small imperfections. Let minor issues slide and enjoy yourself.

Reversed, this card speaks of greed and overindulgence. Enjoying the sweet life, we may overlook glaring issues and problems that must be attended to. We may also be using worldly things to cover up inner pain.

Ten of Cups

The mortal and vampire who embarked on an unlikely affair have beat the odds and somehow made this unusual arrangement work. They clink glasses to their lasting success—he sips a beer while she enjoys a new commercially-available blood substitute that ensures she is no longer in danger of feeding on him.

The deep connection of the cups is made enduring as the tens bring resolution. This is a card of stable relationships that continue to grow and evolve. What it lacks in raw passion it makes up for in balance and durability.

The Ten of Cups asks us to prioritize our relationships, romantic and otherwise, and to work toward alignment and harmony. When it appears, you can trust in those around you and rely upon their good will. Forming strong bonds and commitment takes work but this card says that the work will be worth your efforts.

When a reading concerns any kind of creative work, this card may indicate that it will result in special significance. The whole will be much greater than the sum of its parts.

This card is auspicious for anyone thinking about taking things to the next level or considering settling down in a new location.

Reversed, this card can indicate we are trying to make a situation, in particular a relationship, into something it's not. Rose-colored glasses must come off and we must see others for who they are and listen carefully so that we can truly understand them.

PAGE OF CUPS

A vampire artist stares dreamily at the way the water swirls with the red… pigment that washes off her brushes. The canvas is forgotten for a moment as she contemplates this little miracle in the glass.

Pages embody curiosity and learning. Like students, they explore the many facets of the suit's element, growing along the way. The Page of Cups can be quite the dreamer, visualizing things that others cannot imagine.

As a person, this card represents someone imaginative, sensitive, and whimsical. The Page of Cups may have gifts in the realm of intuition and psychic abilities, receiving messages and visions they can't completely explain. If taken seriously, these talents can be developed further.

This page oozes creativity and may encourage you to discover your own artistic abilities. It may also call you to find a new, unusual, or unexpected approach to the situations you face. Keep things light, make a game of it. A change of scenery might bring needed inspiration. Many would describe this page as unusual, but "usual" people tend to be boring anyway.

This page's emotions easily bubble to the surface and this card encourages you to pay attention to your feelings, especially heightened reactions to a situation. You may discover that your emotional response points to an opportunity to heal an old wound.

Reversed, the page's flights of fancy too often become unproductive daydreams. The search for a new route can leave them going in circles. They may be hypersensitive to criticism and get tangled in emotional messes.

Knight of Cups

A dashing stranger offers a lift on their "steed" and a night of far-away adventures. But first, a sip of something exhilarating from their flask to bring courage.

Knights have grown enough in their suit's element to go out in the world and test their skills. They are seekers and action-oriented. This knight is a born romantic and someone out to do good in this world.

As a person, this card represents someone charming, thoughtful, and deep. They move at a comfortable pace. As their curiosity and interests shift, they happily detour and stop along their path. They are captivated by things they see as beautiful.

This knight wears their heart on their sleeve. They are romantic by nature and will risk pain and loss for a chance at affection and connection. They favor grand gestures and dramatic displays. If you're looking for someone to sweep you off your feet, a Knight of Cups is ideal.

Their romantic soul also extends to their ideals. This knight cares deeply about people in need. This card can indicate that a person needs someone to stand up for them, or it may represent someone who can come to your aid.

This knight is also adept at seeing the beauty in the world missed by others. Go where you feel moved, not where others tell you to.

Reversed, this knight fixates on the tragic end of the emotional spectrum. Their obsession with their own feelings can manifest as moodiness, listlessness, and narcissism. The reversed Knight of Cups can also indicate excesses when it comes to mood-altering substances.

QUEEN OF CUPS

While nearly all vampires feed on the blood of the living, psychic vampires draw their strength from the minds and spirits of others. Legends say this type of predation can ease a troubled brain, but there are whispers that these vampires can leave their prey an empty shell if they desire.

Queens have established an inner mastery of their suit's element. This familiarity makes their actions natural and instinctual, as symbolized by their animal companions. They have a strong influence on others. This queen has an unmatched understanding of the human spirit.

As a person, this card represents someone sweet, caring, and attentive. Their soothing presence puts people at ease, and they are adept at hearing and sensing the unspoken undercurrent in any situation.

The Queen of Cups embodies the essence of water, the element of the heart. They are highly sensitive and adapts to those around them, filling their empty spaces like a liquid seeking to level itself. This makes them emotionally flexible and difficult to catch off balance.

They are often a talented empath, sensing the needs and emotions of others and anticipating their desires. They must learn to build healthy boundaries to protect their own psyche.

This card can indicate that someone needs to be heard—usually at length. It counsels openheartedness, vulnerability, and listening without an agenda to fix or direct. Get ready to go deep.

Reversed, the Queen of Cups gives over too much of their own vital energy to healing and strengthening others, diminishing their own agency and sense of self. They may wallow in a sea of emotions, unable to catch their breath or put their feet on solid ground.

King of Cups

The lord of the manor invites you to take your ease with him. A key to the vampires' survival through the centuries is their skill at cultivating reassuring personas. By this means, they avert suspicion. Such charming people couldn't *possibly* be monsters.

The kings represent an outer mastery of the element of their suit. They have accumulated enough experience and power to command others in their field of expertise. This king excels at understanding the heart and soul of others.

As a person, this card represents someone balanced, open-minded, and warm (at least, warm by vampire standards). The King of Cups is the rare being who can venture into the turbulent sea of emotions while staying calm and composed themselves.

They have a therapeutic effect on others, listening but also guiding them and sharing insights that may have been missed.

This king has a hypnotic way with words. This card may suggest that what will most improve a situation is to have a heart-to-heart with those involved and communicate openly about your feelings.

An important piece of advice for healers is to safeguard their own health. When this card appears, it may mean you are becoming emotionally entangled in someone else's struggles. Put healthy boundaries in place to protect yourself and keep things in line.

Reversed, this king's great heart makes them too soft to be an effective leader. They have been described as the sort of person "everyone likes and no one respects." They may indulge their doubts and insecurities and bring out the weaknesses in others by their example.

The Suit of
SWORDS

The suit of swords is associated with the element of air. These cards represent knowledge, conflict, discernment, reason, strategy, and stress. They portray brilliant ideas and crushing defeats.

There are few beings in this world as lethal as a vampire. The swords in this suit are represented by an array of weaponry and sharp stabby implements. Here you will find the schemes and maneuvers of the most cunning and aggressive vampires alongside their deadliest enemies.

In a reading, these cards will point to mental potential and our capacity for innovation and critical thinking. They also have the dubious honor of representing the more sorrowful experiences in life including heartache, anguish, and defeat.

Ace of Swords

A lethal-looking sword hovers in the air as the delicate hand of a vampire reaches to grasp it. The sharp blade cuts through the mists and the spread wings of the cross guard seem like they could carry the blade aloft at a moment's notice. A single eye gazes out from the center, staring deep into the soul of the vampire's opponent.

The intellect of the swords bursts forth as the ones begin a new cycle. This is a card of fresh starts and new ideas to be explored. It signifies gifts of clarity and insight. Something interesting is about to begin.

The Ace of Swords asks us to look at our situation with fresh eyes and see where we can take things in a new direction. Begin with a mission statement and then build all plans and strategies around maintaining momentum toward achieving that mission.

This card suggests that we cut ties with outdated ideas and ways of being that no longer serve us. Relieved of this dead weight, we can be nimble and fly free. A good place to begin is by clearing our calendars and workspaces.

This card also calls us to seek the truth as objectively as we possibly can. Our emotions, hopes, and fears often cloud our judgment, and when this card appears it's best to view our circumstances dispassionately.

When reversed, something is keeping us from embarking on a new path. We may be using faulty logic that brings us to the wrong conclusions.

Two of Swords

In a moment of perfect stillness, the hunter is calm and focused. A supernatural mist swirls in the darkness making it impossible for them to rely on eyesight in the coming battle. Muscles strain as natural fear and anxiety cry out to make a move, but their training has prepared them for this test. With perfect poise they must wait for their other senses to speak clearly to them, and they will strike only at the most opportune moment.

Twos speak of a desire for the suit's element. In the case of swords, there is a thirst for knowledge. Not knowing what to do is incredibly uncomfortable but choosing without all the necessary information can be disastrous. The Two of Swords reminds you that when faced with a decision, you have the power to decide not to decide. We can give ourselves the luxury of time to consider our options before committing to a path. When you do have enough clarity, the choice will seem obvious. In this way, this card also cautions against hastily made decisions.

The Two of Swords can also signal peace and a pause in conflicts. Opposing sides may experience a stalemate and need to rethink their positions, just as the vampire and hunter may continue to cautiously observe their adversary.

When reversed, the delayed moment of judgment seems to be stalling or obstinacy. We actually may have all the information we need but, for whatever reason remain obstinate, hoping something better will come along. In this case, it's time to move on.

Three of Swords

A mortal awakens in horror to her worst nightmare. Strapped to a cot, she sees three sword-like needles piercing her and drawing her lifeblood from her body. Clearly something happened last night but her mind reels as she tries to piece together the events. She trusted someone, but to them she is only food. Her hands shake in fear as she clutches at the needles.

The sorrows and mental anguish of the swords suit manifest fully in the three and must be dealt with. This is a card of betrayal and pain, the card of a broken heart. It is likely that a past wrong is being held onto. It's very easy to over-identify with an injustice, preserve it in crystal, and focus deeply on our own suffering. But if the blades are not removed, the wound in our heart will fester and prevent healing. Figuring out how to deal with the monster responsible for this will need to wait until the needles are out and straps are untied.

This card is an ill omen when considering future dealings with others. It serves as a warning to guard our hearts and proceed carefully and cautiously (or better yet, not at all). It can also indicate self-sabotage. It is essential to be generous to yourself with your words and thoughts.

Reversed, the Three of Swords is a blessing, reminding us of the power of forgiveness. It heralds a moment when we no longer have a need for old pains or drama—these hurts are finally released and fall away to let the healing process begin.

Four of Swords

Within the shadowed confines of a crypt, a vampire sleeps away the day safely ensconced in her coffin, sheltered by four statues of angels. Light streams in from above but does not penetrate her sacred sanctum. Secure in this knowledge, she can rest at ease in her crystal casket.

The swords are the suit of mental acuity, and the stabilizing power of the four allows our quick and active minds to find peace and calm. Our brains are not machines; pushing them to their limits can dull our intellects.

When the Four of Swords appears, activities and projects tend to pause and the flow of communication stops. This is a time to retreat for as long as you need. You may require a quick walk, a nap, or even a lengthy vacation to recharge your energy. This may be an ideal moment for meditation; in quiet, passive contemplation the answers or new strategies you have been seeking may bubble to the surface.

This is an auspicious card for anyone in need of healing. It points to mind, body, and spirit aligning and repairing as needed. Sleeping under the gaze of angels is very restful for the vampire.

When reversed, this card suggests that the time to rest is at an end and to linger further will lead to stagnation and lethargy. It can also point to holding ourselves back for the wrong reasons, such as fear and self-doubt. It's time to rise and shine.

Five of Swords

A brutal battle has taken place. Two vampires thought they had found an easy target but were surprised to discover there was more to him than meets the eye. Vampires are excellent hunters and have abilities far beyond mortals, but even they need to be cautious before they begin a fight. They were no match for their target. Triumphant, the werewolf howls savagely in the light of the rising moon.

The swords suit is focused on strategy and planning but the fives' tendency toward chaos and conflict turn the situation into an all-out brawl. With the Five of Swords, the strong dominate the weak, and you must take very careful stock of your surroundings to better understand your chances.

The successful strategy here is to be the one who can bark the loudest, silence the opinions of others, and choose to win at any cost. Are you the werewolf who will fight tooth and claw, or are you the vampire who must slink away from this encounter? If this fight is important to you, then this is the moment to stop playing nice and unleash your hidden reserves of power.

If that strategy doesn't seem right, it is best at this time to release attachment to present arguments and find a situation that is safer and more welcoming. The old saying "discretion is the better part of valor" means it is wiser to avoid danger than to confront it.

Reversed, this card represents an opportunity to reconcile your differences with others calmly and peacefully. It requires seeing the humanity in others and the wisdom of their position to find a path of resolution that honors everyone.

Six of Swords

In the dead of night, two vampires make their way to the city docks. Beyond a row of sword-like posts, an intimidating looking boat lies waiting in the water, ready for them to make a speedy retreat. One vampire hesitates, looking back at the world she is fleeing, but her partner places a reassuring hand upon her wrist, urging her to depart these shores.

The strategic calculation of the swords suit is buoyed by the restorative quality of the sixes. This card indicates that the time has come to steer away from conflict and set a course for fresh opportunities.

The Six of Swords urges us to leave behind what is familiar to us and develop new solutions. The brain is unmatched in its ability to take the measure of a situation and form new connections and pathways. This card can insist that we use logic and reason to sort out our situation, breaking it down and addressing it in the simplest, most elegant form.

It also urges us to move on to new challenges that will pique our interests. We can easily overidentify with past selves and responsibilities. When this card appears, it's time to release attachment and design a new reality for ourselves that is aligned with our blossoming interests.

Consider which of the two figures in the card best represents you. Do you need a push in the right direction, or are you tasked with carefully ferrying others to a place of comfort and safety?

Reversed, this card points to unfinished business that needs to be sorted out before we devote ourselves to a new task. Make things right and you will be able to depart in peace without regrets.

SEVEN OF SWORDS

A vampire finds herself confronted by several mortals armed with guns. A human would be finished, but she hasn't been human for a long time and doesn't need to play by their rules anymore. She moves with preternatural speed and grace, easily evading their bullets. Some might call this cheating. These guys should be worried.

The thoughtful strategy of the swords is made even wilier by the adaptability of the sevens. This is a card for finding solutions outside of the box. It ignores conventional wisdom as well as tried and true methods and dares us to think differently. Thinking smarter, not harder, means knowing when to maneuver around blocks rather than bashing ourselves against them over and over. Search for a side entrance or other overlooked avenue you may have missed. This may indicate a need to seek forgiveness instead of permission.

Traditionally, this card is often an indicator that deception or theft is taking place. People are not always as they seem and may conceal their motives. Someone may be trying to trip you up and it is best to be careful with whom you place your trust.

Reversed, this card asks us not to overthink things. Being too clever and trying to skirt the rules could land you in a heap of trouble. You may also be called to reflect on how honest you are being with yourself and others to and take a more open and truthful approach.

Eight of Swords

Some vampires, it would seem, *do* have reflections. In a hall of mirrors, a young human woman finds herself cornered by a vampire with a deadly saber in his hand. Knowing that his prey is confounded by the array of images, he taunts her, striking fear into her heart. If she is to escape from this room with her life, she needs to move in the right direction—a mistake would be costly.

The mental stresses of the swords are deepened by the intensity of the eights. This card suggests that you have found yourself in a difficult situation requiring careful and thoughtful analysis to resolve.

The Eight of Swords calls us to be methodical as we extricate ourselves from our predicament. It is often accompanied by a high degree of mental stress and anguish that threatens to scare us into making a hasty and unwise choice. This card can also appear when we are not able to safely speak our truths. It is best to remain silent for a time and carefully observe our surroundings, trusting our other senses.

In such moments, it is natural to wish that someone will come along and save us. But in this scenario, no one is coming to offer aid and you must get out of this mess by yourself.

Reversed, this card carries a powerful positive message of breaking out of victimhood and bondage. It often appears when limitations on us will be lifted, perhaps when we realize we have limited ourselves unnecessarily and can transcend our present blocks by careful determination.

Nine of Swords

What was that sound? You awaken with a jolt. When you open your sleep-blurred eyes, you recoil in horror at the sight before you. A hideous monster lurks at the foot of your bed, creeping and crawling toward you. Phantasmal daggers hang in the air above you, threatening to drop at any moment. Bright light spills forth from a doorway that seems so very far away. Did you really wake up to this, or are you caught in a bad dream?

The mental focus of the swords is strained by the culminating energy of the nines. This is a card of deep doubts and worries that can gnaw away at us and leave us feeling helpless.

The Nine of Swords is the card of a mind overburdened by stress, responsibilities, and fear. This buildup of mental anguish can lead to fear-based decision-making, disturbing nightmares, and mistrust of others.

Your first priority when this card appears is to become very clear about which of your concerns have genuine merit and which are phantoms. Investigate and communicate until you are very certain of what your true obstacles are.

Alone, dealing with the overwhelming energy this card represents is challenging. Friends can only do so much. You may need the assistance of a qualified professional to help you sort through everything. Seeking help with mental health is a brave and valid choice.

Reversed, this card speaks of a time when fear and worry are dissolved by the clear light of reason. In this scenario, real threats are identified and can be addressed.

Ten of Swords

A vampire warrior writhes in pain after a disastrous confrontation with a mortal hunter. The mortal was far better prepared than the vampire imagined. As he strains to pry blades free, his life's blood seeps out of him and between the stones. If he is to survive the night, he must flee this place and find sustenance to restore his strength. It's not looking good.

The strategies and struggles of the swords are overwhelmed as the tens bring resolution. This is a card of defeat after a difficult battle. It portends failure and ruin; this chapter is ending, making your next decisions and actions critical.

The Ten of Swords asks us to raise the white flag of surrender, accept a loss, and move on from it. When it appears, our present line of thinking should be abandoned. Failure is an incredible teacher. When we learn what not to do, we recover something from the ordeal.

Prolonged stress has a way of taking root in our physical bodies and manifesting as pain, anxiety, and all sorts of other complications. This card can indicate a need to alter one's lifestyle to alleviate these conditions and let healing begin.

Beware of an overemphasis on grit that would cause you to continue to invest in a plan that has not panned out. Those who try the exact same strategy thinking "but this time it will be different," are generally disappointed.

Reversed, this card speaks of blessed relief from difficult conditions. The swords can slip free so that deep healing can begin. It suggests recovery and correction is now possible.

Page of Swords

High up on the ledge of a tall building, mist pours out of a window and materializes into the form of a young vampire. His attire and posture suggest that his mission is one of stealth and secrecy.

Pages embody curiosity and learning. Like students, they explore the many facets of their suit's element, growing along the way. The Page of Swords can be quite the detective, sleuthing for hidden information and gathering all the facts. This card can represent a person who is inquisitive, cautious, and skeptical. They are an ideal resource to reach out to when you are in search of a fresh perspective.

This card may also suggest that you are missing important information about your situation. Before you act, you would benefit from gathering as much as intel as you can.

When they can clear their mind and keep their own biases in check, the Page of Swords can see through smoke screens and penetrate the disguises that people wear. They are excellent at puzzles and problem solving. This may be a sign that careful consideration is required. Don't take things at face value, see what lies beneath the surface.

Reversed, the Page shifts from sleuth to spy, violating privacy and disrespecting boundaries with gossip and backbiting—sharing secrets and spreading rumors. This card reversed can also indicate that you are drawing the wrong conclusions from the information you have collected.

KNIGHT OF SWORDS

A vampire warrior springs into action, leaping toward her prey. Her blades fly forth as quickly as she can throw them, finding their targets with deadly accuracy. Nothing can withstand her merciless onslaught.

Knights have grown enough in their suit's element to go out in the world and test their skills. They are seekers, and action oriented. The Knight of Swords brings a special intensity to their mission.

As a person, this card represents someone direct, intense, and impulsive. They act first and ask questions later (or never). They are adept and skilled, attending quickly to what is needed.

"He who hesitates is lost" and the Knight of Swords doesn't like to lose. This is the swiftest of the knights. Their card urges us to act quickly and decisively. They rely on instinct, making fast judgments about people as well.

This card reminds us to not indulge in worry about what will happen three or four steps down the road. That's just borrowing trouble. Focus on the here and now and make the best decision you can with the information you have.

The Knight of Swords has no use for regrets. They've already moved on to the next fork in their path. Let go of what has already happened. Give up hope for a different past.

With the card reversed, this knight easily leaps into disaster. A reversed knight tells you to slow down and assess things more thoughtfully. Look before you leap.

QUEEN OF SWORDS

The deadly lady offers a wry smile as she draws her slim blade from its unobtrusive cane. She has been underestimated before and, like the falcon on her shoulder, is quite good at sizing up her prey.

Queens have established an inner mastery of their suit's element. This familiarity makes their actions natural and instinctual, as symbolized by their animal companions. They have a strong influence on others. This queen has sharpened her intellect to a razor's edge.

As a person, this card represents someone clever, witty, and self-assured. Her keen mind is valued by others who will often seek her opinion when a difficult decision must be made. Her tongue may be sharp, but you would do well to value her judgment. She doesn't miss much.

The Queen of Swords has an excellent sense of discernment. She can quickly assess most situations and determine what is working and what is not. She can seem cold because she values attaining her desired goals more than she values interpersonal relationships.

When she appears in a reading, it often means something should be cut out of our lives. Take a good honest look at your situation and try to clarify if and how you might be fooling yourself.

Reversed, this Queen's forthrightness sours into viciousness. She may see everyone around her as a competitor and keep them at a distance—sometimes with barbed words and unkindness. She can be manipulative and cruelly calculating, using people for her own ends.

King of Swords

The war chieftain of the vampires sits atop his throne, resting his hand on the skull of a vanquished enemy—a trophy of his victories and a reminder of his own vulnerabilities. A claymore stands at the ready, eager to see further service in battle.

The kings represent an outer mastery of the element of their suit. They have accumulated enough experience and power to command others in their field of expertise. This king is the ultimate strategist, planning for every eventuality and circumstance.

As a person, this card represents someone shrewd, methodical, and logical. They can be relied on to create the most sensible plan of action. Their ideas tend to be both efficient and effective.

When the King of Swords appears in a reading, it is time to think about long-term strategies. It is easy to get wrapped up in our immediate needs. This card advises you to set these concerns aside for the moment and cast your mind's eye forward several months or years from now. Make decisions and take actions that will advance your long-term goals.

This king does not shy away from suffering or hardship when it serves their ultimate ends. Sacrifice immediate gratification to build future success. They are also adept at giving clear directions. Leave nothing to chance and be certain people understand what is expected of them.

Reversed, the king's focus on the big picture may cloud their perception of the present moment. They may be ruthlessly, stubbornly ambitious to the detriment of themselves and others. Consider where you might to dial things back a bit.

The Suit of
PENTACLES

THE SUIT OF PENTACLES IS ASSOCIATED WITH THE element of earth. These cards represent resources, finances, work, solidity, strength, and manifestation. They portray the rewards of success and the drudgery of toil.

Vampires' virtual immortality allows them to accumulate great wealth and power for themselves. The pentacles are depicted as the seal of the Eternal Order, a shadow government made up of elite vampires who meddle in the affairs of mortal nations and manipulate the world in accordance with their designs.

While the other three suits describe ineffable and invisible things, in a reading, pentacles show us that which is real and tangible. The cards in this suit tend to indicate areas where hard work and dedication are needed in order for us to create and manifest our dreams.

ACE OF PENTACLES

A vampire's hand bursts forth from the earth covering its grave—the first act of a strange and powerful new existence. On the headstone is the seal of the Eternal Order, the vampires' hidden ruling council. Its emblem, a fanged skull in a pentacle, denotes the immortals' victory over death, their reign on Earth, and the vast resources at their command.

The material concerns of the pentacles form a foundation as the ones begin a new cycle. This is a card of abundant resources and success. Something prosperous is about to begin.

The Ace of Pentacles asks you to invest in your future success by establishing a firm foundation. Plant a seed that you will commit to nurturing and maintaining until it reaches its full potential.

Sometimes when pursuing a goal, we can get caught up in dreaming, consulting, and planning, when what is needed is a single determined concrete step forward. Imagination, creativity, and strategy are meaningless if they are not supported by the mundane activities that will fulfill our plans in this world. This card connotes manifestation and moving from the realm of ideas into reality.

This is an auspicious card for anyone considering a new job or a career move, as it indicates the incredible potential of the chosen path.

Reversed, you have planted your seed in infertile soil, and it will be unable to take root and thrive. It would be better to involve yourself in a venture with more potential.

Two of Pentacles

One of the great challenges for any newly made vampire is to balance their human lives and loves with their new existence as an undead. Balancing on a ladder, a novice vampire carefully considers two paintings. One depicts his human family; the other, his immortal sire. With only one nail it seems a choice is looming. But is there another way for him to proceed?

Twos speak of a desire for the suit's element; in the case of pentacles, it is a desire for stability and groundedness. The Two of Pentacles points to a precarious time, as you must maintain a tricky balance in your life. Work and home, family and friends, responsibility and play—when vastly different interests demand our focus, it requires both will and skill to keep our sense of equilibrium. You must make good use of your resources, in particular your time and your attention.

As challenging as this all sounds, the card also suggests that you have the wherewithal to juggle different interests and responsibilities successfully. Sometimes we need to stretch ourselves thin. The Two of Pentacles may indicate you can choose *both* instead of one or the other. All good things come to those who hustle.

This card asks: Are you prioritizing what you truly value?

Reversed, the balancing act is too hard to maintain. Push yourself too far and you will topple. Identify what can be set down, or who can be relied upon to help you shoulder some responsibility.

Three of Pentacles

As the sun sets, a clandestine meeting takes place high above the urban sprawl. A member of the vampires' ruling council is joined by a police captain and priest to discuss matters at hand. Red circles mark out a map of the city and packets bearing the seal of the Eternal Order are placed before the leaders.

The industriousness of the pentacles is made manifest in the threes. This card signifies the magnificent things we can create when we collaborate effectively with others. The Three of Pentacles recommends that we make use of our greatest talents and skills and partner with those whose abilities will complement our own. You will accomplish much more when you can focus on what you do best and delegate tasks to others.

This card is auspicious for all forms of creation. If there is something you are ready to make, to write, or to bring into being, this is the time. It also cautions us to pay close attention to the finest details of our plan. If you value what you are bringing forth, then choose to love and respect it, and work hard to make it as perfect as possible.

Above all else, it asks us to move beyond the blueprint phase and begin building something that will last.

Reversed, this card suggests that there is a flaw in our design. It can point to miscommunication with our teammates, preventing us from sharing the same vision.

Four of Pentacles

When the sun is in the sky, a vampire must sleep, and it is during these daylight hours that they are most vulnerable. To compensate, this vampire has enclosed their coffin in an impregnable vault protected by reinforced steel, lasers, hidden traps and a very loyal Doberman familiar. Nothing will get past their safeguards.

The stability of the fours and the groundedness of the pentacles make this card unshakable. The Four of Pentacles suggests a focus on what is real and material in the situation. It is also a card of prioritizing your needs above all others and keeping everything that belongs to you under lock and key. This card recommends that right now, we invest our finances and other resources in ourselves, not in those around us. Resources here can mean money but also time—a most precious commodity for mortals.

The walls indicated by this card can form an impenetrable barrier, keeping all others out. They can signify the extreme greed and miserliness that results from a fixation on acquiring wealth and prestige. People who have more than they need and don't share it can be very unpopular.

Reversed, the Four of Pentacles is an invitation to relax the barriers a bit and let others inside. These walls that keep problems at bay also keep you locked away from the rest of the world.

Alternatively, it can be a warning that your money, time, and energy are being spent on something that will ultimately fail. Be prudent and wise when it comes to both saving and spending.

Five of Pentacles

In a darkened alleyway, a teenager hides in the shadows of trash cans, out of view of the glaring lights. Trembling fingers reach toward his mouth, feeling teeth that have somehow become sharp. A line of gold coins forms a pathway out of the alley and directly toward the police car. The police might have helped him as he was before. But how will they treat him now that he has become … something else?

The material resources of the pentacles are debilitated by the chaos and unbalanced energy of the fives. This card heralds difficult times when we lack the resources—time, energy, or money—that are required. Even worse is the sense that the authorities and institutions who should come to our aid are nowhere to be found. We may find we are alone, fending for ourselves in a cold, cruel world.

The Five of Pentacles can indicate that we are stretched too thin, overcommitted, neglecting to care for ourselves, not refueling in a healthy way. We may find ourselves indebted to others without knowing how we will satisfy that debt.

In such times, our physical bodies may enter survival mode, releasing hormones to help us act in a moment of need. If we spend too long in this stressed state, we can experience constant, overwhelming tension, anxiety, fear, and sleeplessness. Take care of your body and its needs.

Reversed, this card indicates that we will receive the help we need if we reach out and ask for it. Lean on both people and institutions and accept the support they offer.

Six of Pentacles

In a darkened hospital room, a vampire in a lab coat injects a thin stream of her own blood into a sleeping patient's IV bag. The blood of a vampire has powerful healing properties, and we see that it glows with light as it travels into the patient's veins. Her wounds seem severe but the magic in the blood will speed her recovery.

The practical concerns of the pentacles are made generous by the healing powers of the sixes. This card asks us to look at our lives and identify patterns of give and take. There are often areas where the time, energy, and money we spend on something are not equaled by the benefits. We are called to refocus our attention and reallocate our assets where they can do the most good.

The Six of Pentacles speaks of generosity. It is wonderful to give of yourself and your wisdom to those who will truly benefit from it. Someone close to you may need service, care, and consideration.

This card also points where the greatest need is: material resources, very often money, but also labor and advocacy. Some problems cannot be solved with creativity, gumption, and cleverness. Identify what is truly necessary to improve unfortunate conditions.

Reversed, this card asks us to refocus care and attention on ourselves. Being overly giving can cause the well to run dry. The people we care about are not well-served if we work ourselves into a state of fatigue.

Seven of Pentacles

A vampire tends to her poison garden of purple nightshade, foxglove, datura, poison ivy, hemlock, oleander, and even a particularly remarkable Venus flytrap. These deadly lifeforms are delicate, but their caretaker has uncovered a great secret. Her lifeblood makes an invigorating fertilizer; for life, after all, feeds on death. Sometimes you have to pour yourself into your work.

The stability and dependability of the pentacles are extended by the adaptability of the sevens. This card advises you to cultivate the virtue of patience. It also points to long-term goals and endeavors that require steady effort and sustained investment.

The Seven of Pentacles also recommends taking a step back and evaluating our progress. How have our expectations panned out so far? Do we have what it takes to see things through properly? This is not a rush job; it needs a sustained, steady beat to succeed, a committed effort to bear fruit.

The Seven of Pentacles reminds us that an enterprise may appear stagnant, but often the real magic takes place beneath the soil. If we rush or cut corners, the fields will be fallow. Growth takes time.

When this card is reversed, you must reconsider your expectations for this project. Your rewards will not be equal to your efforts, and you must decide whether you can invest even more of yourself into this project or whether you must let it go.

Eight of Pentacles

A vampire artisan sits beneath the great seal of the Eternal Order, the sign of the undead reign over this world. He labors over a set of designs, seeking to improve upon the perfection of centuries.

The structure and dependability of the pentacles is deepened by the eights. This is a card of thorough, careful work. It appears when we must focus our time and effort on other people's projects rather than on our own passions.

The Eight of Pentacles speaks of the advantages of learning something by doing it. With an apprentice's mindset, we improve our skills by implementing the tried-and-true methods, making improvements only when we have gained enough experience. Some things cannot be rushed. We might wish to get by with the willpower, creativity, and cleverness of the other suits. But sometimes what is really needed is hard work and commitment. This card rewards steadfastness and professionalism. Our efforts are rewarded as our creations take shape over time. This card can also point to a need to attend to the most minute details.

This card often indicates a time of boredom and drudgery. We find ourselves working for other people's benefit. Keep trudging along and your reward will be the satisfaction of a job well done.

Reversed, this card suggests that all the grunt work is needless suffering, and you will benefit from setting it aside and focusing on that which brings genuine pleasure.

Nine of Pentacles

On a quiet evening, the lady of the manor plays the piano in her favorite room. It's uncanny how much that ancient Roman bust resembles her. Perhaps that's why she acquired it? The hand-painted wallpaper is exquisite and, she claims, original to the house. Apparently, it's been in her family for a long, long time.

The material wealth of the pentacles bears fruit when paired with the culminating power of the nines. This is a card that shows us all the advantages of keeping true to your own vision of success.

The Nine of Pentacles asks us to define how we will invest our time, energy, money, and other resources to maximize the benefits they bring. It urges us to carefully organize and orchestrate our lives to manifest our creative vision. This requires sacrifice, as nothing of value comes free. In a world filled with distractions, it takes incredible discipline to honor our plans and commitments. This card encourages you to work for what you want and enjoy what you've earned after it has been achieved.

Prioritizing and adhering to our own plans and desires can sometimes make us feel cut off from others. You are, after all, your own royalty. Self-reliance can appear aloof or even predatory—a side effect of being "The Boss."

Reversed, this card speaks of burnout and working too hard for rewards you don't get to truly savor. Self-sufficiency has become loneliness and ambitions turn to regrets. Be certain you are working hard for the right reasons.

Ten of Pentacles

The newly made vampire we met in the two has made his choice and sired a new chosen family of his own. They are unique individuals united in their admiration and devotion to one another. Their pooled skills and abilities have brought great wealth and success to their clan. The manor house will welcome and protect new members as the family grows.

The wealth and resources of the pentacles become a fortress when brought to completion by the tens. This is a card of great abundance and indicates prosperity and plenty.

The Ten of Pentacles asks us to make use of the resources around us and to remember our roots. The success depicted here is the sort that is passed down through generations, so we should consider what we have received from our predecessors and the legacy we are creating for the future.

Just as a braided rope is harder to cut, when friends and families unite, they lend each other strength. Just as you support those in your circle, their strength is available for you to draw upon.

This is an auspicious card for questions relating to work or finances, suggesting a prosperous outcome of the venture at hand.

Reversed, the warm face worn by the family is a façade. Although the collective appears strong and stable, there are cracks and divides that threaten the collective. Fractures must be healed, or the structure will crumble.

Page of Pentacles

You had to imagine there were quite a few vampire lawyers. Through its functionaries, the Eternal Order has maintained an ironclad grasp on much of mortal civilization. When claws and fangs are inadvisable, contracts are indispensable.

Pages embody curiosity and learning. Like students, they explore the many facets of the suit's element, growing along the way. The Page of Pentacles has a can-do attitude and a willingness to roll up their sleeves and get their hands dirty.

As a person, this card represents someone pragmatic, down-to-earth, helpful, and focused. They are excellent at doing the necessary "grunt work" others may avoid. This card suggest that it's best to leave strategizing to others and instead apply yourself to tactics. What is the task at hand? What is the next step? Focus on practicalities, work steadily, and bit by bit the job will get done. Have you read the instructions?

This hands-on page learns best by doing. If you find yourself a little overwhelmed by theory and background, skip ahead, get down to business, and just see how you do.

This is an auspicious card for anyone considering advancing their career. It represents the needed step of paying one's dues and working your way up the ladder.

Reversed, the page may not see the forest for the trees. They can become too wrapped up in the details and miss essential context or background information, like the emotional, political, and interpersonal aspects of the situation.

Knight of Pentacles

Sturdy and strong, the vampire bodyguard bearing a shield emblazoned with the sign of the Eternal Order checks in with her commanders. Her devotion to the Order's rule is unwavering and she will lay down her eternal life in defense of its principles.

Knights have grown enough in their suit's element to go out in the world and test their skills. They are seekers and action oriented. This Knight is a calm, dependable person who will see any venture through to the end.

As a person, this card represents someone helpful, serious, and patient. They take the slow but certain route to their destination. Of all the knights, they are the least interested in taking risks or chances.

This card often comes up when a project requires simple dedication and hard work. There are no fancy tricks up their sleeve; no out-of-the-box options. For them, the only way out is through, and they keep their eyes on the prize until the tasks are completed.

To serve their straightforward approach, they develop and master methods and routines with predictable outcomes. This conservative approach to tasks can conserve a great deal of time, energy, and money.

As a companion, no one is more faithful than this knight. They will defend their allies to the end. This card can indicate a need to not get blown off course by turbulence or shifting emotions. Stay the course.

Reversed, the knight's tried and true methods have become outdated, and a fresh perspective is needed. The reverse orientation describes a dry, dull, and monotonous existence.

QUEEN OF PENTACLES

In a garden, the queen bathes her skin in the light of the waxing moon. She has laid out everything she needs for maximum comfort and, though undead, she has surrounded herself with things that grow. Her faithful greyhound waits by her side.

Queens have established an inner mastery of their suit's element, making their actions natural and instinctual, as symbolized by their animal companions. They are quite influential to others. This queen knows all about the finer things in life.

As a person, this card represents someone nurturing, sensual, competent, and wise. They understand the value in arranging things to set the right tone and mood.

The Queen of Pentacles understands the critical relationships between mind, body, and spirit and the importance of comfort to all three. When one of these dimensions of experience is out of whack, it means trouble for the others as well. Ask yourself: "What does my mind, body, and spirit need?" and then give those things to yourself. Self-care is essential for our continued functioning and well-being.

They are as generous with others as they are with themselves. When this card appears in a reading, it may indicate that someone needs pampering, nourishing, grounding, or energetic cleansing to set them at ease and help them heal.

Reversed, this queen's generosity can become consuming, draining their own life to please others. Their appreciation for finery overextends into materialism and conspicuous consumption. This card may suggest that superficial appearances can mask deeper problems. Don't judge a book by its cover.

KING OF PENTACLES

The lord of the vaults is the keeper of one of the vampire's most precious resources: their hidden blood reserves. Managing their hunger and finding ways to supply it has kept the vampires safe. His responsibility for their stockpile makes this king extremely powerful.

The kings represent an outer mastery of the element of their suit. They have accumulated enough experience and power to command others in their field of expertise. This king is a peerless businessman, creating structures and enterprises that stand the test of time

As a person, this card represents someone resourceful, steady, and driven. No one excels them in dedication and discipline.

Their success comes from a life of careful effort and going the extra mile for maximum effectiveness. This card may ask you to push yourself to stay focused on the task at hand and reject distractions. Keep your eye on the prize; let irrelevant projects and concerns fade into the background.

This is an auspicious card for matters concerning wealth and finances, and points toward future abundance. It reminds us that to reap a satisfying harvest, we must make a significant investment in the here and now. Take the extra time, effort, and expense to do the right thing in the right way and you will be proud of what you have manifested.

Reversed, the king's drive and ambition can lead to "all work and no play." This might be a good moment to lighten up. Their zeal for success may make them greedy and controlling. No amount of material success can spark the soul like love of life itself.

The Night Is Young...

Like the life of a vampire, the education of a tarot reader never ends. Your practice will be strengthened and deepened as you encounter new perspectives and ideas in the many books, articles, videos, and lessons created by other students in this exciting field. As your tarot practice is your own expression of your sacred relationship with the divine, I encourage you to adopt the techniques and meanings that empower you as a reader and release those that don't. You will also have your own mystical insights about the tarot and its uses, and I recommend that you share them with our community. In this way, you will forge many wonderful connections with your fellow travelers.

We who dwell in this shadowy world, at the margins of polite society, also have a duty to those who haven't pursued this study. They will make their way to us seeking answers they cannot find in the ways familiar to them. To be an oracle is to be able to guide ourselves and others into the liminal space where we can encounter our true selves, receive understanding, and be transformed. Be kind to them and be kind to yourself.

To Write to the Author

If you wish to contact the author or would like more information about this book, please write to the author in care of Llewellyn Worldwide Ltd. and we will forward your request. Both the author and publisher appreciate hearing from you and learning of your enjoyment of this book and how it has helped you. Llewellyn Worldwide Ltd. cannot guarantee that every letter written to the author can be answered, but all will be forwarded. Please write to:

Charles Harrington
c/o Llewellyn Worldwide
2143 Wooddale Drive
Woodbury, MN 55125-2989

Please enclose a self-addressed stamped envelope for reply, or $1.00 to cover costs. If outside the U.S.A., enclose an international postal reply coupon.

Many of Llewellyn's authors have websites with additional information and resources. For more information, please visit our website at http://www.llewellyn.com